Artemisia Gentileschi

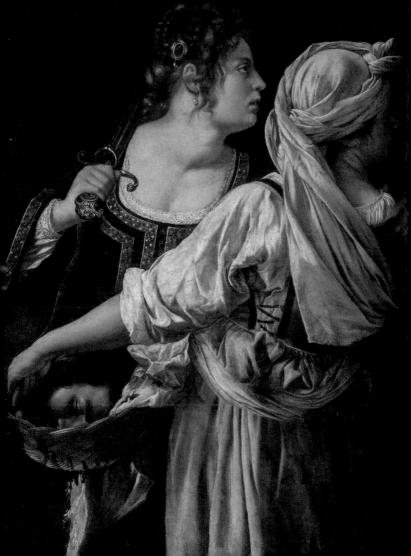

Lives of Artemisia Gentileschi

Artemisia Gentileschi

Orazio Gentileschi

Cristofano Bronzini

Pierantonio Stiattesi

Filippo Baldinucci

Averardo de' Medici

Alessandro Morrona

edited and introduced by

Sheila Barker

J. Paul Getty Museum, Los Angeles

CONTENTS

*Opposite: Pierre Dumoustier le Neveu, The Hand of Artemisia
Gentileschi Holding a Paintbrush, 1625*

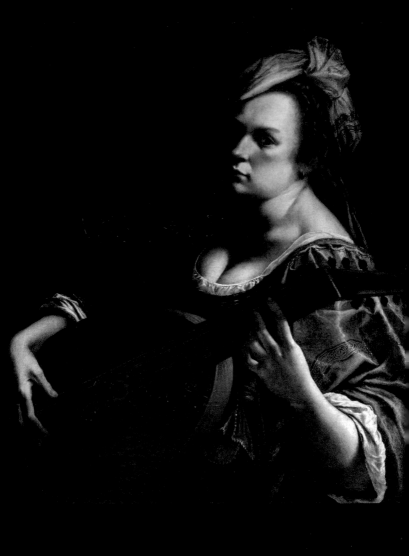

INTRODUCTION

SHEILA BARKER

LIFE

Almost by definition, early professional women artists were mould-breakers who chose exceptional paths. Yet even by this special measure, Artemisia Gentileschi's life would still be judged an extraordinary one. Born in Rome on 8 July 1593 to a Florentine painter named Orazio Gentileschi (1563–1639) and his wife Prudentia Montoni, Artemisia lost her mother at the age of twelve, becoming the sole female in her household. She learned to paint shortly thereafter, emulating the art of her father as well as that of Caravaggio and the Carracci. Within six years, she had completed her first masterpiece — the *Susanna and the Elders* dated 1610 (Schloss Weissenstein, Pommersfelden, ill. p. 21) —, was giving drawing lessons to apprentices, and was fulfilling commissions for portraits and possibly also religious themes.

The following year, Agostino Tassi (1578–1644), a landscape painter who had recently collaborated with

Opposite: Self-portrait as a lutenist, 1616-18

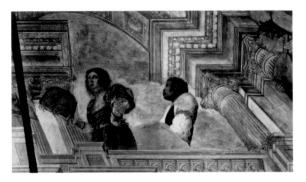

Presumed portrait of Artemisia, from a fresco painted by her father (the figures) and Agostino Tassi (the perspective, in which he was a specialist), 1611-12

her father, took advantage of Orazio's work-related absence to enter the Gentileschi home uninvited. He burst into Artemisia's private painting studio on the upper floor, overpowered her and raped her, buying her silence afterwards with false promises of marriage. Upon finally discovering what had happened, Orazio brought charges against Tassi, leading to a trial in which witnesses were questioned about Artemisia's virginity and her reputation in the neighbourhood, issues that had a bearing on the legal definition of sexual assault in seventeenth-century Rome. Included in this book is a long extract from Artemisia's own testimony, in which she astutely indicates all the conditions necessary for Tassi's assault to

qualify as a punishable crime in juridical terms, and in which she paints herself as an unimpeachable and sympathetic victim. It is, in a sense, a form of autobiography.

Although Tassi was found guilty, the exposure of the trial had harmed the young girl's chances for Roman patronage. Thus, by means of an arranged marriage to a Florentine man named Pierantonio Stiattesi, Artemisia left Rome and restarted her career at the Medici court beginning in 1613. During her seven years in Florence she underwent financial challenges, the deaths of three children, the wreckage of her adulterous affair with a younger man named Francesco Maria Maringhi, frequent displacements of her household and workshop, continuous legal trouble over her debts with servants and shopkeepers, and even accusations of theft. Yet many triumphs and honours were hers in the same period. She attained the patronage of the grand duke of Tuscany; she gained significantly in literacy and social graces; she made the acquaintance of other bright talents like the playwright Michelangelo Buonarroti Junior (1568–1646) and the painter Cristofano Allori (1577–1621) — not to mention Galileo Galilei (1564–1642); and she produced several of her greatest masterpieces in her opulent and operatic brand of naturalism.

Overleaf: Venus and Cupid, c. 1625

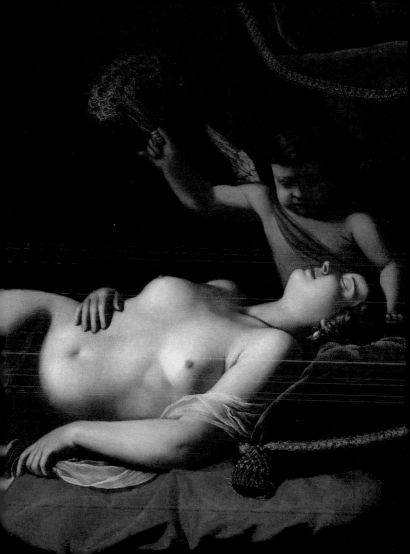

Forced out of Florence by family scandals, she tried to resume her career in Rome beginning in 1620, but the conditions for this were inauspicious. Not only did she endure the death of yet another child (leaving her with just one daughter), but she was also tormented by deep rifts with her father and brothers and the growing jealousy of her cuckolded husband. A brief interlude in Venice, from roughly 1626 to 1630, rewarded her in many ways. For example, she learned from the large scenographic canvases of Veronese and Tintoretto how to compose complex, multi-figural actions, and how to work the material of the paint more loosely and expressively. She also made important friendships: a younger female painter named Giovanna Garzoni (c. 1600–1670), several poets, and Fernando Afán de Ribera, the Duke of Alcalá (1583–1637), a powerful Spanish diplomat with a passion for paintings.

Thanks to Alcalá, Artemisia received not only several lucrative religious commissions, but also an invitation to set down roots in the Spanish Kingdom of Naples in 1630. Whatever inducements she received from him were redoubled by the willingness of Garzoni to accompany her, as well as the worrying course of a deadly outbreak of bubonic plague in the cities of northern Italy. On her way south, Artemisia stopped in Rome long enough to reignite an abiding connection with the erudite cultural

czar of the Barberini court, Cassiano dal Pozzo (1588–1657), who managed many of her later commissions and who received a self-portrait from the artist, if not other works as well. He remained a lifelong supporter and ally.

Although the artistic community of Naples was to give a hostile reception to the Carracci school painter Domenichino (1581–1641), who arrived in the city a year later, it warmly embraced Artemisia. One of the ways Artemisia won their favour was by inviting many of the local artists — such as Domenico Gargiulo (1609–1675) and his Lombard colleague Viviano Codazzi (1604–1670) — to collaborate with her. Furthermore, she is remembered by the biographer Bernardo De Dominici for having given valuable artistic guidance to an older Neapolitan painter, Massimo Stanzione (1585–1656) who learned from her by visiting her studio and copying her paintings.

After Artemisia settled in Naples, she wrote in 1636 to Andrea Cioli, a powerful minister at the Medici court, seeking his help in finding a better situation in Florence. She was not enjoying the street violence in Naples, nor the high cost of living. But the appeal to Cioli led nowhere, and in the event Artemisia is only known to have left Naples once. Through the intervention of Dal Pozzo and Cardinal Francesco Barberini, she and Giovanna Garzoni were sent to London in 1638 as part of a

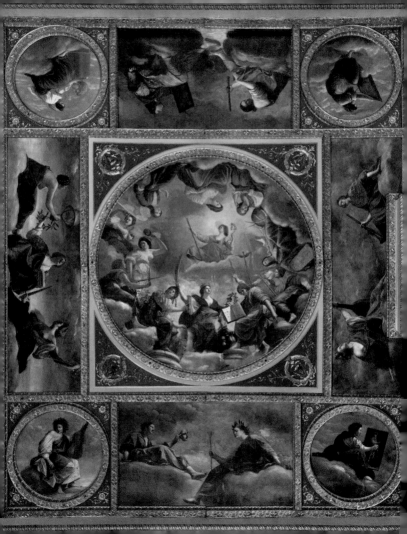

soft diplomatic campaign to coax Charles I into lending support to the Catholic cause in England. The timing of the journey could not have been more critical, for it allowed Artemisia to comfort her father in his final days. Orazio, who had been in Charles I's service since 1626, would pass away in London in February 1639. Artemisia remained in London at least another year after her father's funeral.

Upon her return to Naples, she increased her reliance on the artists in her workshop such as Onofrio Palumbo, and perhaps Bernardo Cavallino as well, to fulfil the orders coming from nobles throughout Europe up through the early 1650s — the period of the last traces of her activity. One of her most fervent collectors in this period was a patrician of Messina, Don Antonio Ruffo (1610/11–1678), who wrote to the artist frequently to indicate his subject preferences and to speed along her progress. Artemisia's spirited and self-assured responses say little about her domestic life. They focus instead on her professional concerns and challenges, on the superior value of her original and ingenious artistic compositions, and on the fierce defense of her capacity as a woman. Beyond some financial papers dating from 1654, there is

Opposite: An Allegory of Peace and the Arts, a ceiling for the Queen's House, Greenwich, painted by Orazio Gentileschi with assistance from Artemisia, 1635-38

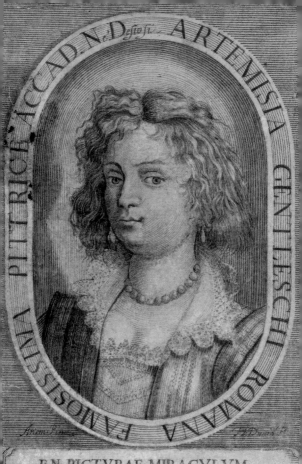

EN PICTVRAE MIRACVLVM
INVIDENDVM FACILIVS QVÀM IMITANDVM

no later evidence for her life, and thus it has often been reasonably been proposed that she, like many other Neapolitan artists, perished in the plague of 1656.

LEGEND AND LEGACY

Fame was one of the few constants in Artemisia's tumultuous life. Eventually her name resounded from Sicily to London, and in terms of celebrity she easily outstripped all of her female predecessors. Today, she is the subject of popular feature films, documentaries, best-selling historical fiction, graphic novels, theatrical performances, scholarly publications, and seven major museum exhibitions in just over a quarter century.

From a tender age, Artemisia had grabbed the spotlight as the first female painter of her era to excel in history subjects. This prestigious genre had previously been assumed to be beyond the reach of women because of its demanding cerebral components. Her earliest secure work, the *Susanna and the Elders* of 1610, was a perfect

Opposite: Self-portrait of Artemisia Gentileschi, engraved by Jérôme David, c. 1628. The inscription calls her 'most famous', and 'a miracle of painting, easier to envy than to imitate'. The original painting after which the engraving was made has been lost

machine for promoting the reputation of its sixteen-year-old maker. With this debut piece, Artemisia not only demonstrated her skill in history painting, but she also rose to a challenge no previous female artist had ever attempted: a full-length nude on a large scale. Moreover, Artemisia portrayed her nude Susanna having her same age and features similar to her own. That physical resemblance encouraged a potentially scandalous connection between the artist and the nude figure she had painted, and viewers must have wondered if they were seeing a nude self-portrait of the pretty young daughter of Orazio Gentileschi in the guise of a blameless Biblical heroine. The identification was further encouraged by the proximity of Artemisia's signature to Susanna's pale legs, appearing like an inscription in the stone on which her bare body rests. Presented with skill and wit, it was this audacious feminine self-presence in Artemisia's paintings that was to become her artistic trademark. In a Roman art market crowded with imitators of Caravaggio, Artemisia's vivid, luminous, and womanly brand of Baroque naturalism commanded all eyes.

The quest for fame was a perilous enterprise for a woman in seventeenth-century Rome, where genteel women cloistered themselves within their homes so as

Opposite: Susanna and the Elders, c. 1610

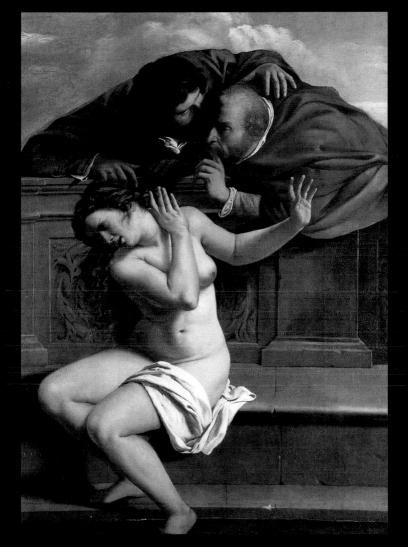

not to be seen or spoken of. This presented a dilemma for a young artist whose work as a history painter required a knowledge of the world and the affairs of great men. When her father brought a trial against Agostino Tassi in 1612 for having raped his seventeen-year-old daughter the previous year, a number of witnesses took pains to mention that Artemisia had sometimes been seen from the street as she gazed out of a window in her house. One witness said she did this 'very impudently' ('molto sfacciatamente'). From these critical, chastening tongues, Artemisia learned at a young age that even the smallest transgressions of the spatial and social boundaries of the private sphere could be devastating for a woman's standing, especially if she was unmarried.

Challenged but not discouraged, Artemisia from this moment forward took full command of her reputation. She lost no time in restarting her professional career under more propitious conditions, wedding a Florentine man named Pierantonio Stiattesi the day after Tassi was pronounced guilty. As soon as the autumnal rains abated, she moved to her husband's native city where, distanced from the Roman gossip, she took measures to put herself in the best light possible, even feigning a level of prosperity she had not yet attained. She made connections with gentlemen at the Medici court through her husband's mercantile network, she invested heavily

in a wardrobe befitting of a noblewoman, and she employed servants to carry out domestic chores and to do menial tasks in her workshop. Although fully occupied with painting her early masterpieces for the Grand Duke of Tuscany and raising her small children, she somehow found the time to learn to write and to acquire the gloss of humanistic education that would serve as her passkey to elite cultural circles not only in Florence but throughout Europe.

It is in this period of earnest self-fashioning that Artemisia, by then in her late twenties, fortuitously crossed paths with Cristofano Bronzini, a courtier engaged in the writing of a polemical defense of women. Entitled *Della dignità et della nobiltà delle donne ('On the Dignity and Nobility of Women')* and dedicated to the Medici grand duchesses, this treatise, despite its importance, was never published except for some small excerpts. Because Bronzini's treatise employed both historical figures as well as contemporary ones in order to demonstrate women's continuous capacity for greatness, he must have been well disposed to including Artemisia as an example of a latter-day heroine, especially since she enjoyed the favor of his Medici patrons. Referring to the artist by her nickname 'Mizia,' his vignette is now recognized to be

Overleaf: Esther before Ahasuerus, after 1628

23

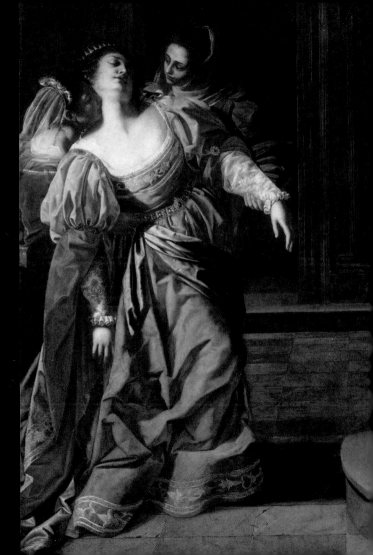

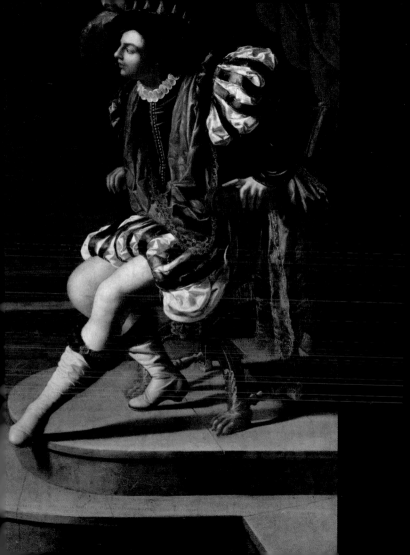

not only the earliest biography of the artist, but also the product of Artemisia's own heavy-handed intervention.

Artemisia's biography is unlike all the others in Bronzini's treatise. Its radically distinct format and style indicate that it was not composed by Bronzini himself, whereas its inclusion of strikingly intimate details — like its allusion to the lonely self-reliance of a young girl growing up without a mother to mend her clothes — could have only been supplied by Artemisia herself. The biography's fictitious claim that her father sent her to a convent to dissuade her from painting, as well as its glaring omission of two defining points of her childhood — namely the artistic training she received from her father and her tragic involvement with Agostino Tassi — both betray Artemisia's compulsion to portray her Roman childhood not the way it happened, but in a way that would make a good impression on her Medici patrons. Even more to the point, Artemisia's narrational focus on her juvenile predisposition to creativity rather than her accomplishments as a mature artist would seem to show that she cared at least as much about conforming with Giorgio Vasari's typecast of the outlier artistic genius as she did about blending in with Bronzini's repertoire of women worthies.

Opposite: David and the Head of Goliath, c. 1639

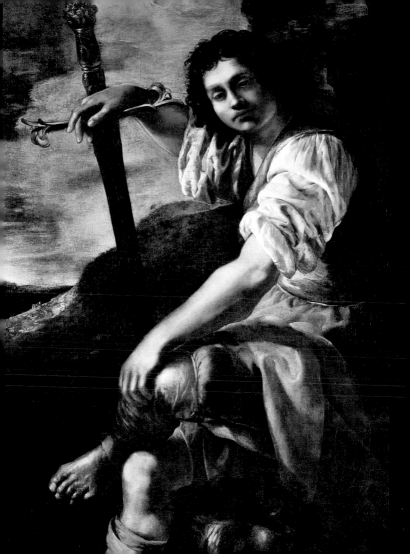

If there is one conclusion that emerges from the biography of Artemisia in Bronzini's treatise, it is that Caravaggio's paintings played a defining role in her stylistic formation. Curiously, however, none of the other biographies that were written about the artist during the next two centuries made any mention at all of Caravaggio's artistic influence. Instead, they invoke other artists as her stylistic models: her own father, naturally, but also such painters as Guido Reni and Agostino Carracci. Their characterizations of Artemisia's artistic thumbprint can be attributed not only to the gradual attenuation of Caravaggesque elements in Artemisia's painting style, but also to developments in the æsthetic canon by which artists were judged.

Vital for understanding the continued appreciation of Artemisia's paintings well into the late eighteenth century are the writings of early connoisseurs such as Filippo Baldinucci (1625–1696), a Florentine *literato* who expanded and updated Vasari's artist biographies with his *Notizie dei Professori del disegno ('Biographical notices of the teachers of drawing')*; Averardo de' Medici, a Florentine patrician who researched Artemisia's life and œuvre after acquiring a painting of hers in Naples, probably in the 1780s; and Alessandro da Morrona, a cleric who corresponded with Medici while compiling biographies of artists and other illustrious natives of Pisa. These later

writers, although not contemporaries of Artemisia, have been included here not only because of their valuable insights into the evolving assessment of her style, but also because a comparison of their biographies suggests how the story of Artemisia's rape (which was not widely known until the twentieth century) slowly began to appear in print in direct connection with her biography.

Baldinucci, who completed his biography of Artemisia in 1682, had seen four of her canvases, all in Florence: *Inclination* (Casa Buonarroti; ill. p. 151), *Aurora* (Alessandra Masu collection, ill. p. 152), the *Abduction of Persephone* (now lost), and *Judith Beheading Holofernes* (Uffizi, ill. p. 78). The first two of these were female nudes; indeed, Baldinucci informs us that the figure in *Inclination* used to be completely exposed before the painter Volterrano added drapery for modesty's sake. More than for its nudity, however, the *Inclination* impressed Baldinucci because of the woman's expressiveness and character, appearing to him 'very lively and self-assured,' a phrase that recalls what we have said above about the audacious feminine self-presence in Artemisia's paintings. With regard to the *Aurora*, Baldinucci found it worthwhile to describe the protagonist's unusual running pose in detail, yet he praised it above all for the lovely colouring of the flesh that is bathed on one side in crepuscular half-light. Baldinucci's stupor was well founded: no

one before Artemisia had ever calibrated Caravaggesque tenebrism to achieve such ornamental effects with the delicate light of foredawn.

Publishing his vignette in 1792 (the same year that Morrona published his work), Medici introduced personal observations about Artemisia's style while building upon Baldinucci's biography. For instance, he noted her skill in painting complex, large-scale compositions, and in doing so he sharply contradicted Bernardo De Dominici's criticisms in his biography of Massimo Stanzione (published in 1742). In defending her compositional capability, Medici invoked three works that had never before been mentioned in print. Among these were her two canvases for the apse of the cathedral of Pozzuoli — although here Medici mistakenly assigned her the *Beheading of St Januarius* rather than the *Adoration of the Kings* (or even *Sts Proculus and Nicæa*) (all still in situ; ill. opposite). The third work was a painting in his own possession: the *Susanna and the Elders* (Pinacoteca Nazionale, Bologna, ill. pp. 172-73). This canvas was praised by its owner for its ability to express the chastity of Susanna in opposition to the lechery of the Elders, and for the 'skill, delicacy and texture' of the brushwork that makes Susanna's skin appear touchable and supple.

Opposite: Adoration of the Kings, c. 1636-37

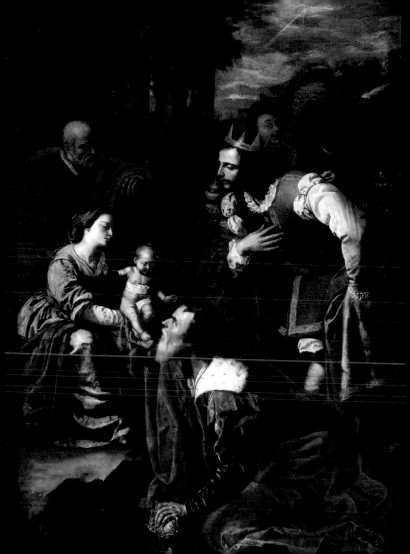

If those abovementioned qualities do not resemble the standard litany of Caravaggesque stylistic traits, it is because Medici instead saw Artemisia in relation to Bolognese classicism, a style which was enjoying a great revival at the time Medici was writing. For Medici, although Artemisia's manner was 'utterly original,' he also considered that her imitation of flesh by means of impasto along with the 'texture, delicacy, singular grace, and good taste' of her painting style made it hard — even for connoisseurs — to distinguish her works from those of Guido Reni and Domenichino.

The early biographies provide frustratingly few reliable details about her working methods. Her father Orazio is said to have been her teacher by most of the early sources (Baglione, Baldinucci, Medici, Morrona and even Orazio Gentileschi himself in his letter of 1612 to Grand Duchess Christine de Lorraine), yet Bronzini's account, which Artemisia oversaw, denies this point vehemently. While this was perhaps self-serving hyperbole, it is perhaps more significant that Bronzini's account places emphasis on the importance of Caravaggio as a guide for Artemisia's artistic formation. Indeed, her shift to the use of dark grounds after 1610 would seem to confirm her imitation of his working practice.

Since so few drawings are currently attributed to her (and none with universal endorsement), it is particularly

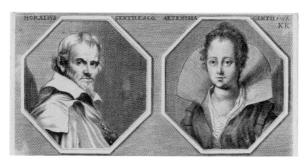

Portraits of Orazio and Artemisia Gentileschi reproduced in the 1683 edition of Joachim von Sandrart's Teutsche Academie

noteworthy that one early biographer, Joachim von Sandrart, referred to Artemisia's proficiency in drawing in his 1675 *Teutsche Academie* (The German Academy) a passage that is cited here in its entirety given its important status as the first stand-alone life of our artist to be published:

> No less praise was earned by the virtuous Artemisia Gentilesca, to whom I carried — when I was in Naples [1631] — the greetings of her father the very famous Horatio Gentilesco, my extraordinary dear Friend. She showed me her lovely paintings: among others one life-size picture of a graceful David holding in his hands the horrifying head of gigantic

Goliath, and near it the many other works very cleverly wrought by her hand. She had also produced some exceptionally fine portraits, and at the Academy she drew with excellence. Therefore, she was held in esteem not only by the Viceroy's consort [Leonor María de Guzmán] but also by all the other princesses, and from everyone she received great acclaim and renown.

It can be presumed that the drawings she made at an academy were (nude) life drawings, this activity being one of the standard functions of art academies at a time when using live models for mere practice was prohibitively expensive for individual artists. Although Sandrart did not specify at which academy she made her drawings, it must have been the Accademia delle Arti del Disegno in Florence, given that there is no evidence of her attendance of the artists' academy in Rome, and that the other two academies which she is known to have frequented were both dedicated to purely literary pursuits.

Also relevant to Artemisia's study of art is her request for a copy of one of Sandrart's own paintings: a candlelit scene of *The Death of Cato* (Musei Civici, Padua) with an orderly composition that evokes Poussin's classicizing style. Sandrart gave a copy to her when he visited her

studio in Naples, as recounted in his autobiographical essay:

> At the frequent requests of the young woman Artemisia Gentilesca (who had an excellent style in large-scale painting and who also was the daughter of Horatio Gentilesco, the latter having patrons in London, I might note), he [Joachim von Sandrart] repeated his depiction of the History of Cato Uticensis [Cato the Younger] based on Plutarch's vivid description and in nocturnal illumination, to her great delight and high praise.

Without question, Artemisia's early biographers concerned themselves primarily with her art. Nevertheless, they did occasionally open small windows onto the difficulties and setbacks that punctuated her life away from the canvas — a most unconventional life by any measure. We have already seen how Bronzini's biography touched on Artemisia's solitary childhood following the premature death of her mother. Morrona in 1792 was the first of her biographers to draw attention to her rape at the hands of Agostino Tassi. This story had not surfaced at all before the posthumous publication in 1772 of Giambattista Passeri's life of Agostino Tassi in his *Vite de' pittori scultori ed architetti che hanno lavorato in Roma*

(*'Lives of the painters, sculptors and architects who have worked in Rome'*). In Passeri's account of the contested events, it is clear that the author's sympathies lay with Tassi, his subject, rather than with Artemisia, portrayed not as a virgin but as a charming coquette. In paraphrasing Passeri, Morrona subtly reinforced that bias, expressing pity for the man who 'endured prison' because of his 'excessive familiarity with his beloved Artemisia'.

Markedly more defensive of Artemisia's honour in her private affairs is Medici's biography. Medici not only omitted reference to Tassi altogether, but he even doubted that Artemisia's husband, Pierantonio Stiattesi, was truly worthy of her, citing Stiattesi's common birth and his apparent lack of a professional status (indeed, no guild memberships for Stiattesi have ever been located). Through Medici's quotation from De Dominici's biography of the Neapolitan painter Massimo Stanzione, we learn that Stiattesi accompanied Artemisia to the seat of the Spanish viceroyalty in 1630. Unfortunately, Medici perpetuated some of the misunderstandings introduced into Artemisia's biography by previous authors, and principally Morrona. These errors include the mistaken birth year of 1590 (rather than 1593), the misrepresentation of her birthplace as Pisa (rather than Rome), the misspelling of her husband's surname as 'Schiattesi' (rather than 'Stiattesi'), and the baseless association of her with still

life painting and the representation of fruit in particular, perhaps due to confusion with her contemporary and friend, Giovanna Garzoni. Nevertheless, Medici did substantially rectify her death date (which has yet to be established with precision). Pointing out that his own painting of *Susanna and the Elders* was signed and dated 1652, he proved that Artemisia did not die the previous decade as was once assumed.

Artemisia's letters tell about sides of her life that were not easily reconciled with the conventions of artists' biographies. Hinged on the moment and shockingly raw, some of those letters were never meant for any eyes but those of the recipient. This applies above all to the flurry of hastily written notes addressed to Artemisia's Florentine lover Francesco Maria Maringhi (or to his alias 'Fortunio Fortuni') in the years 1620-21, immediately following the completion of the Uffizi *Judith Beheading Holofernes*. Slightly younger than Artemisia, this undistinguished merchant would have instantly faded from history had Artemisia not confided in him during the difficult years of her marriage when she lived apart from her husband. The letters to Maringhi portray an exhausting existence beset by tribulations and enemies, and powered by a maelstrom of mercurial passions. Her two children are mentioned only once in these tense exchanges. Instead, it is her paintings that concern her

most, and she bursts with pride when announcing her professional successes.

By contrast, some of the other letters that Artemisia penned are thoughtfully and even quite artfully composed. Those addressed to patrons and well-placed allies, such as Galileo Galilei, Cassiano dal Pozzo, and Don Antonio Ruffo, were written with the expectation that others would read them, preserve them, and possibly publish them, as often occurred in that century with the letters of famous literati. This category of Artemisia's writings are thus invaluable sources for understanding how she wished to be seen and appraised in the public sphere. They show how consistently she endeavoured to be taken seriously as an artist and to be judged and treated by same standards as her male colleagues. Here in these letters, in fact, we encounter the strongest and clearest verbal statements of her feminist perspective.

These centuries-old writings that trace the trail of Artemisia's bright star do more than just establish the contours of her œuvre. They furnish an invaluable treasure for the admirers of her paintings wishing to understand the extraordinarily spirited and ingenious artist who made them, and they bear witness to a remarkable woman who, without any particular advantage in life except her talent, reached for the greatest glory.

*Extracts from the testimony at
the trial of Agostino Tassi
for the rape of
Artemisia Gentileschi*

1612

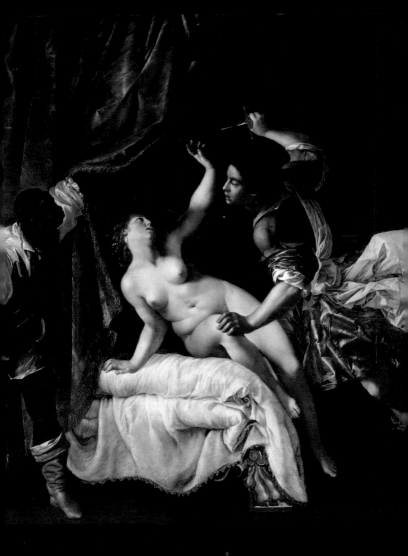

Signora Artemisia, daughter of the painter Signor Orazio Gentileschi, was questioned in her Roman house, the place of her usual dwelling, located overlooking the hospital of S. Spirito at the foot of the hill, by magnificent and excellent Lord Roberto Bulgarello, the substitute deputy, and by me, etc.

Having been ordered to …. To tell the truth, and after she had sworn under oath the examinee was asked by the judge whether she knew the reason she was being interrogated.

She answered: I can imagine the reason Your Lordship wants to question me because for the past few days I have watched my father's activities, and he has had the tenant who lives in the upstairs apartment, named Tuzia, put in prison, [for she] has plotted to betray me by taking part in having me disgraced.

Asked the reason that she asserted what she imagined, and asked to state and relate how she was betrayed by the said Tuzia, and what had been fabricated by [Tuzia] against her reputation.

Opposite: The Rape of Lucretia, c. 1645-50

She answered: Regarding the disgrace and betrayal that, as I mentioned above, was perpetrated by Tuzia against me, I want to say that she acted as a procuress to have me deflowered by a certain Agostino Tassi, a painter. In order that you be fully informed about the whole thing, I shall relate in detail the facts as they happened. Last year, when my father lived on Via della Croce, he rented the apartment upstairs to the said Tuzia, who had come to live there about two months before. My father was a close friend of the said Agostino Tassi who, because of this friendship, began to visit our house frequently and to become friends with the said Tuzia. One of the times he came was the day of Santa Croce last May, and the said Tuzia tried to persuade me that Agostino was a well-mannered young man, courteous to women, and that we would get along very well with each other. She pushed me so much that she convinced me to speak to the said Agostino, having stated beforehand that a servant who used to be with us was going round spreading scandal about me, and that Agostino would let me know what [the man] was saying. Since I wanted to know what the servant named Francesco had said, I decided on that day of Santa Croce to talk to Agostino, who had been let in the house by Tuzia. In my conversation with Agostino, he told me that Francesco

was boasting that I had given him what he wanted. I replied to him that it didn't matter what Francesco was saying because I knew what I was, and I was a virgin. He then told me that he was upset by the fact that Francesco was saying these things about me, because of his friendship with my father and because he valued my honour very much, and without going into any further details, he left.

The following morning when I was in bed and my father had left the house, the said Agostino came again, accompanied by Cosimo, orderly of our Holy Father, and Tuzia let them in. When I heard people walking up the stairs I threw on my dress and went upstairs to her apartment. When I saw that the people who had arrived were Cosimo and Agostino, I greeted them, and turned to Agostino and said: 'You even want to bring that man here,' meaning Cosimo. Agostino told me to be quiet, and when I had calmed myself down Cosimo came toward me and tried to persuade me to be nice to Agostino because he was a well-mannered young man who deserved the best. When I refused to do that and showed that I was disgusted by the way he was treating me, he added: 'You have given it to so many, you can give it to him as well.' Enraged, I then told Cosimo that I had little respect for the words of scoundrels like him, asked

him to relieve me of his presence, and turned my back on him. He then began to say that he was joking, and finally Cosimo and Agostino left. I was upset by these words for several days, and my father was distressed because I didn't want to tell him the reason I was upset. Tuzia took this opportunity to tell my father that he ought to send me out for walks because it was bad for me to stay home all the time.

The following evening Agostino sent me a message through one of Tuzia's boys that he wanted to have a few words with me that evening, and along with this message he sent Tuzia a piece of cloth to make a small cape for one of her children. When I heard this message I turned around and said: 'Tell him that [it isn't proper to] talk to unmarried women in the evening.'

The following morning my father told Tuzia that since she had spoken of taking me out, she should take me, and [he asked her] to take me as far as S. Giovanni, believing that she was a respectable person. While we were preparing to go out that morning, Cosimo and Agostino appeared, having probably been informed by Tuzia the evening before that we were planning to go to S. Giovanni. They talked with Tuzia who [then] wanted to take me to a vineyard. When I heard this, I got angry and said I didn't want to go to a vineyard, and in any case they should get

out of my sight. They went about their business, and we went to S. Giovanni, where I saw Cosimo and Agostino close by. As I left the church Cosimo stayed back and Agostino followed me, coming closer and closer. But because I complained about it, he followed me at a distance all the way home. While I was at home, the parish Fathers dropped by to pick up the holy cards for Communion and left the door open. With that, Agostino took the opportunity to come into the house and, on seeing those Fathers, began to boast that he could beat them up, speaking to himself so that they couldn't hear him. Then he left, but as soon as the Fathers had gone, he came back and began to complain that I behaved badly towards him and that I didn't care about him, saying that I would regret it. And I answered: 'Regret what, regret what? He who wants me must give me this,' meaning marry me and put a ring on my finger. I turned my back on him and went to my room and he left.

On the same day, after I had eaten lunch, as it was a rainy day, I was painting an image of one of Tuzia's boys for my own pleasure. Agostino stopped by and managed to come in because one of the masons who were working on the house had left the door open. When he found me painting, he said: 'Not so much painting, not so much painting,' and he grabbed the

palette and brushes from my hands and threw them around, saying to Tuzia: 'Get out of here.' And when I said to Tuzia not to go and not to leave me, as I had previously signalled to her, she said: 'I don't want to stay here and argue, I want to go about my own business.' Before she left, Agostino put his hand on my breast and as soon as she was gone he took my hand and said: 'Lets walk together a while, because I hate sitting down.' While we walked two or three times around the room I told him that I was feeling ill and thought I had a fever. He replied 'I have more of a fever than you do.' After we had walked around two or three times, each time going by the bedroom door, when we were in front of the bedroom door, he pushed me in and locked the door. He then threw me onto the edge of the bed, pushing me with a hand on my breast, and he put a knee between my thighs to prevent me from closing them. Lifting my clothes, which he had a great deal of trouble doing, he placed a hand with a handkerchief at my throat and on my mouth to keep me from screaming. He let go of my hands, which he had been holding with my other hand, and having previously put both knees between my legs with his penis [membro] pointed at my vagina [natura], he began to push it inside. I felt a strong burning and it hurt very much, but because

he held my mouth I couldn't cry out. However, I tried to scream as best I could, calling Tuzia. I scratched his face and pulled his hair and before he penetrated me again I grasped his penis so tight that I even removed a piece of flesh. All this didn't bother him at all, and he continued to do his business, which kept him on top of me for a while, holding his penis inside my vagina. And after he had done his business he got off me. When I saw myself free, I went to the table and took a knife and moved towards Agostino saying: 'I'd like to kill you with this knife because you have dishonoured me.' He opened his coat and said 'Here I am,' and I threw the knife at him and he shielded himself, otherwise I would have hurt him and might easily have killed him. However, I wounded him slightly on the chest and some blood came out, only a little since I had barely touched him with the point of the knife. And the said Agostino then fastened his coat. I was crying and suffering over the wrong he had done me, and to pacify me, he said: 'Give me your hand, I promise to marry you as soon as I get out of the labyrinth I am in.' He added: 'I warn you that when I take you [as my wife] I don't want any foolishness,' and I answered: 'I think you will see if there is any foolishness.' And with this promise I felt calmer, and with this promise he induced me to yield lovingly,

many times, to his desires, since many times he has also reconfirmed his promise to me.

When later I heard that he had a wife I reproached him about this betrayal, and he always denied it, telling me he didn't have a wife, and he always reaffirmed that no one but himself had had me. This all happened between Agostino and me.

She added afterward voluntarily: And I was even more certain about the promise that Agostino was going to marry me, because every time there was a possibility of a marriage, he prevented it from developing.

Asked whether, at the time when she had been as violently deflowered as she asserted by the said Agostino, she discovered after the fact that she was bleeding in her pudenda.

She answered: At the time when the said Agostino violated me, as I said, I was having my menstrual period and therefore I cannot tell your Lordship for certain whether I was bleeding because of what Agostino had done, because I didn't know much about these things. It is quite true that I noticed the blood was redder than usual.

She added afterward voluntarily: Indeed, after the first time, on many other occasions I bled when the said Agostino had carnal relations with me. And when I asked him what this blood meant, he said it came

because I had a weak constitution.

She added afterward: Every time Agostino had
carnal relations with me, it took place in my home,
both here and in the house on Via delle Croce. When
it was here, where it took place most of the time, he
entered through Tuzia's apartment, when a door
that connects the two apartments was open. When
the door was locked, he would nonetheless come to
Tuzia's place to see what I was doing. He never went
anywhere with me except one day this August. When
I was about to go to S. Giovanni, the said Agostino
came to meet me on the Lungara, and with great im-
pertinence, he opened the door of the carriage and
jumped inside, along with another fellow named Mas-
ter Antonio, and made the coachman go toward S.
Paolo so that he would not be seen. When we reached
S. Paolo, he and I got out of the carriage and went for
a walk in the fields there. Then we climbed back in
the carriage and returned home; he got off at Ponte
Sisto. Tuzia, her aunt Virginia and Tuzia's children
were with us.

She added afterward voluntarily: I also remember
that I had talked with the said Agostino this Carni-
val at the house of Cosimo the orderly, where Ago-
stino came after I arrived and in that house I talked
with the said Agostino in the apartment downstairs

where Cosimo's wife had taken me. She went back upstairs and Cosimo stayed at the door to keep watch in case my father arrived. After a while he came back inside and said: 'It's your loss if you haven't done your business.'

Asked whether the examinee had acted carnally with any other person than the said Agostino.

She answered: No, Sir, I never had any sexual relations with any other person besides the said Agostino. It is true that Cosimo made all sorts of efforts to have me, both before and after Agostino had had me, but never did I consent. One time in particular he came to my house after I had been with Agostino and made every effort to force me, but he didn't succeed. And because I did not consent, he said that he was going to boast about it in any case and would tell everyone, which he has done with numerous people, particularly Giovan Battista and his sister-in-law, as well as with Agostino, who because of all this indignation, withdrew from wanting to marry me.

Asked whether the examinee herself was ever given anything by the said Agostino and if so, what.

She answered: The said Agostino never gave me anything because I would not want that, since what I was doing with him I did only so that, as he had dishonoured me, he would marry me. Except that last

Christmas he gave a pair of earrings as a present and I gave him twelve handkerchiefs.

She added afterward voluntarily: I also wish to inform you of something else, that the evening before Agostino was put in jail he and Cosimo came to Tuzia's place and all three of them got together and agreed on what they should say in case they were arrested. This was told to me by my godfather, the painter Pietro Rinaldi.

MONDAY, THE FOURTEENTH DAY OF MAY, 1612

Agostino Tassi, as referred to elsewhere, appeared again in the presence of the illustrious and excellent Lord Geronimo Felice, deputy, and the illustrious and excellent Lord Francesco Bulgarello, substitute deputy, and me, the notary writing this, and in the presence of the magnificent and excellent Lord Porzio Camerario, substitute judge.

Having been ordered to tell the truth, and to swear under oath, he was asked by the judge whether he needed to say anything else voluntarily in addition to what he had testified in other depositions, and whether he intended to add something to it or subtract from it.

He answered: I don't need to say anything other than what I have said in my other testimony, nor do I have anything to add or subtract.

Asked whether, at last ceasing his obstinacy, he would be willing to tell the truth about whether he had raped and had sexual relations with the said Artemisia, Orazio Gentileschi's daughter, about which he had been questioned other times.

He answered: No, Sir, I have spoken the truth and I am telling you that not only have I not raped the said Artemisia, but I have never had sexual relations with her.

Asked what the witness would say if the said Artemisia should be brought before him, and, after having been told by me everything that had been discussed above, she should confirm it and accuse him of falsehood, he answered: I will say, every time Artemisia tells me to my face that I have had relations with her and that I deflowered her, that she is not telling the truth.

Then the judge, in order to prove to the witness that his previous statement was a lie, and even more, to prepare him to speak the truth, as well as for any other good end and result, ordered that the aforenamed Madam Artemisia, [daughter] of Orazio Gentileschi, be brought before the witness.

After she was brought in and they were both or-
dered to swear to tell the truth, etc., and having both
recognised each other's person and name, she, the one
who was summoned, was asked by the judge whether
her testimony some days ago about the witness here
present was and is true, and whether she intended to
confirm and substantiate now, before the witness here
present, that what she had testified was true.

She answered: Yes, Sir, what I said some days ago
in my testimony before Your Lordship about the per-
son Agostino Tasso here present is the truth, and for
the sake of truth I am ready to confirm and substanti-
ate it here in front of him.

Asked now to relate the aforementioned deeds in
their essence, she answered: I have told Your Lordship
on other occasions that last year during the month
of May, Agostino here present used to frequent my
father's house, as he was a friend of my father and in
the same profession. He came to the house as a friend
and both my father and I trusted him. One day he
came to the house under certain pretexts, as I have
related at other times in my testimony, and as I have
said, I trusted him and would never have believed that
he would dare rape me and do damage both to me
and to the friendship he had with my father. And I
did not realise it until he grabbed me by the waist,

threw me on the bed, closed the door of the room and embraced me to rape me and take away my virginity. Even though I struggled for a while, the struggling went on until eleven o'clock, since he had come after dinner as I said in my other testimony, to which I refer. And the bed post was what protected me until that hour, since I was holding tight and turned toward it.

And as they were writing down these things, the aforenamed witness [Agostino] said voluntarily: Write down in print everything that she says and note that she maintains that the struggling lasted until eleven o'clock.

Then the judge ordered that, for their information, I the notary should read [the transcript of] the examination that the aforenamed summoned woman had undergone at another time, as stated above, during the course of the trial on the 28th of March. And after I had read it, and the two of them had listened to it carefully, as they declared, the summoned woman was asked by the judge if what she had just heard read corresponded to what she herself had testified at another time during her examination, and whether all that she had testified was the truth, and whether she was now willing to confirm and substantiate all this before the witness himself.

She answered: I heard the testimony that you had your notary read here, and I recognise that it is the testimony I gave at another time. Everything contained in this I have testified in truth, and in truth I now confirm it here before Agostino.

The questioning witness [i.e. Agostino] then said: I say this, that everything that Signora Artemisia said and put down on paper is a lie and not the truth at all. That I have raped her is not true, nor that I have had relations with her, because in her house there was a stonecutter called Francesco with whom you couldn't trust a female cat; and he had been alone with her both during the day and at night. [And there was] Pasquino from Florence, who boasted publicly that he had had Signora Artemisia. And I visited her house with that honour and respect which one must show in a friend's house. I have not deceived either my friend nor her, and I have always avoided going there because they used to get me involved in continual fights. In conclusion, everything that she has said is untrue.

The summoned woman [i.e. Artemisia] then replied: I say this, that everything I have said is truth, and were it not truth I would not have said it.

The summoned woman was asked whether she was prepared to confirm her aforesaid testimony and

deposition, as well as everything contained in it, even under torture.

She answered: Yes, Sir. I am ready to confirm my testimony even under torture and whatever is necessary. Indeed, I want to tell you more, that when I went to S. Giovanni that man gave me a twist that I did not want.

Then the judge, in order to remove any mark of infamy and any doubt that might rise against the person of the said summoned woman or about the things she had said, from which she could appear to be a partner to the crime, and most of all, to corroborate and strengthen her statement, as well as to all other good ends and results, and, even more, to affect the person of the said summoned woman, in the presence of the witness, to be submitted to the torture of the thumb-screw, taking into consideration that she is a woman, seventeen years old, as one can tell from her appearance. The prison guard was called in to proceed with the said torture and, before he affixed the cords upon the summoned woman, she was questioned and admonished to beware of unjustly accusing the said Agostino of rape, yet insofar as it is true, she should not change the account as she gave it, because if the truth indeed appears to be as the summoned woman testified in her examination, she should not hesitate

to confirm everything, even under the said torture of the thumbscrew.

She answered: I have told the truth and I always will, because it is true and I am here to confirm it whenever necessary.

Then the judge ordered that the prison guard put on the thumbscrew and… her hands before her breasts, that he adjusted the cords between each finger, according to … and practice, each in the presence of the witness [Agostino]. And while the guard tightened the… with a running string, the said woman began to say: It is true, it is true, it is true, it is true, repeating the above words over and over, and then saying, this is the ring you gave me, and these are your promises.

Asked whether what she had testified in her examination and had just now confirmed in his presence was and is true, and whether she wished to sanction and confirm it under the said torture, she answered: It is true, it is true, it is true, everything that I said.

The said questioning summoned man then said: It is not true, you are lying through your teeth.

The said summoned woman reporting: It is true, it is true, it is true.

Since both of them stood by their statements, the judge ordered that the thumbscrew be untied and

removed from her hands. She remained there just long enough to say a Miserere and then [the judge] dismissed the said summoned woman.

And when he was about to dismiss her, the witness said: Don't let her go, because I want to ask her some questions.

And when the judge asked him to explain what he wanted to say, he answered: These are the questions I wanted to ask. And he showed a certain page on which were written certain questions, which the judge asked the said summoned woman.

She was asked:

1. Who made you testify against me, where did he approach you, and with what words? And who was present?

And to the first [question] she answered: It is truth that has induced me to testify against you and no one else.

2. Tell me exactly how and with what opportunity I first had relations with you, as you assert, and where?

And to the second one she answered: I have said so much about that this evening that I think it should be enough, both about the place and the time that it had happened.

3. Tell me how I frequented your house. Tell me if anyone else frequented it, and who they were.

To the third one she answered: I have already spoken about how he frequented my house, and many people frequented my father's house, gentlemen and noblemen, but no one came on my account.

4. Tell me the truth Artigenio [and] unknown others frequented your house, and you are warned that if you deny this, it will be proven [with evidence], etc.

To the fourth question she answered: The aforementioned Artigenio was a procurator for Cardinal Tonti. He was a friend of Tuzia, and he frequented her house, but he did not frequent mine.

And while they were writing this down, the witness said: Ask her whether she has ever done a portrait for the said Artigenio.

And the said woman answered: Yes, Sir, I was asked to paint a portrait of a woman who he said was his beloved, and I did it. What do you have to say about that? It was Tuzia who sought me out to do this portrait.

5. Tell me what opportunity brought the said men to your house.

The fifth she answered as above.

6. Tell me, did your father know and did he see the said men and me when we came to your house?

To the sixth one she answered: When Artigenio frequented Tuzia's apartment my father saw him as

he went in and when he came down. My father was painting and Tuzia said: 'Come over and see [this] Signor Artigenio,' and he went into the said room to watch my father passing over the paintings, and they talked. As for Agostino here, he used to come to the house at times, but when he came for me, [my father] did not see him.

7. Tell me, did your father provide for your needs?

To the seventh one she answered: Yes, Sir. My father provided for my needs.

8. Did he make you want for anything? Did he leave you alone with men in the house?

To the eighth one she answered: My father has never left me alone with any man.

9. Were you ever alone in the house with men, and particularly with said men [such as] Francesco Scarpellino?

To the ninth one she said: I was never alone with Francesco Scarpellino, because my brothers were also there, one of them was sixteen years old.

10. Did you ever complain that your father made you want for anything?

The tenth one she answered as above.

11. Did you ever tell anyone that Pasquino had deflowered you?

To the eleventh one she said: When Pasquino

stayed in my house, I was not more than seven years old, and I never said that he had deflowered me.

12. Tell me, is it not true that a man deflowered you?

To the twelfth one she referred to the next one.

13. Did you ever write letters to anyone, and what did the said letters contain?

To the thirteenth, she answered: I cannot write and I can read very little.

14. To what end, and with what hopes, did you give this testimony?

To the fourteenth, she answered: I testified with the hope that you would be punished for the wrong that you did.

15. Say why you were forced, as you claim.

The fifteenth was omitted as it was not pertinent.

16. What protest did you make? Did you shout? And why didn't you make any noise?

To the sixteenth, she said the same as in her examination: Because he gagged my mouth and I could not shout.

17. What are the signs that a virgin shows when she has been deflowered? Say it, and say how you know it.

To the seventeenth, she said: I said in my testimony that when he raped me the first time, I was having my period, and I noticed that the menstrual blood was redder than usual.

18. How was it when you were deflowered, what signs appeared in you?

To the eighteenth, she gave the same answer as in her testimony.

19. Have you told anyone that I deflowered you? Whom did you tell and to whom did you brag of it, and to what end?

To the nineteenth, she said: I told Stiattesi and his wife that you had deflowered me, and you also told Stiattesi.

20. How long after it happened [did you tell]? Why didn't you tell it immediately, and, if immediately, why didn't you bring suit? Why have you said it now and what induced you to say it?

To the twentieth, she said: I told Stiattesi that you had deflowered me when he came to live in our house in December. And you had told him before, but I also told him. We didn't bring suit earlier because something else had been arranged so this disgrace would not become known.

21. Who found out you had been deflowered? Why, under what circumstances, and when?

To the twenty-first she answered: You disclosed to Stiattesi that I had been deflowered.

22. Were you hoping to have me as a husband?

To the twenty-second, she said: I was hoping to

have you as a husband, but now I don't, because I know that you have a wife.

23. Did anyone tell you that I would be your husband if you were to say that you had been deflowered by me?

To the twenty-third, she said: No one told me this, but I have seen it as truth.

24. In what manner did it occur when you were deflowered?

[No answer to this question is recorded.]

And having set aside the said testimony, the judge dismissed the said summoned woman and ordered that the witness be taken to his place, etc.

ACCOUNT OF MARIO TROTTA,
THE TWENTY-THIRD DAY OF JUNE, 1612

Mario Trotta, an apprentice 'learning to draw' declares that Orazio had evicted from his house his nephew Giovanni Battista, now dead, who had told him that Artemisia spent time at the window. During the winter, Trotta worked with both Orazio and Agostino in the Palazzo del Quirinale for three *giulii*

a day. According to Trotta, Orazio keeps himself to himself, his only friends are Agostino, Quorli, and the keeper of the Vatican fountain. Orazio employs day labourers. Trotta does not know Artemisia. He has heard she was a virtuous woman but has also heard that she was seen by Carlo Saraceni standing 'very brazenly' at the window. He does not think that the comings and goings in Orazio's house would cause rumours. Mario Trotta was not included by Orazio in the list of false witnesses.

ORAZIO GENTILESCHI

Letter to Christine de Lorraine, Grand Duchess of Tuscany

1612

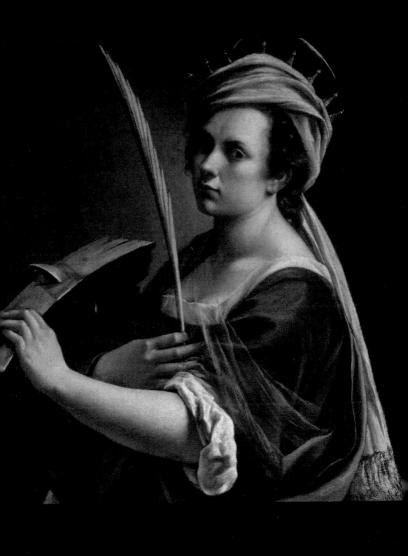

Most Serene Highness,

My duty as a vassal should have impelled me to make myself known to Your Most Serene Highness far earlier than this, but as I had hoped to present myself in person, I had allowed myself to be tardy. But since a most urgent reason forces me to make myself known by a letter, I beg you to give a benevolent ear to what I must with the greatest reverence tell you.

Your Most Serene Highness will know that I have lived in this city [Rome] for thirty six years, and that during all this time I have employed myself in virtuous tasks, in particular, in the profession of painting, in which my principal goal was to reach the heights of other famous men, attempting in all that I do to accomplish great things worthy of honourable men.

I have a daughter and three sons; and this daughter, thanks be to God, having been educated by me in the profession of painting, has in three years reached such proficiency, that I may dare say that she has no equal, for she has now made such works that perhaps

Opposite: Self-portrait as St Catherine, c. 1615-17

the great masters of this profession cannot reach the level of her knowledge, as I will be able to show your Most Serene Highness in the right time and place. And as, two years ago, a certain Agostino Tassi arrived in this city, a painter of the happy memory of the Most Serene Grand Duke Ferdinand, your husband, I, through other friends, joined him in close friendship. Leading me to understand that he intended to introduce me through Signor Lorenzo Usimbardi* to work for their most Serene Highnesses, he showed himself in little time to be a most devoted friend, and I, in reciprocal affection, not only loved him, but also, while he was in prison for carnal rela-tions with one of his sisters-in-law, used powerful connections to save him from the gibbet. That is why, as Agostino demonstrated his gratitude fulsomely, I was obliged to help him paint the Royal Saloon, built by His Holiness in the Quirinal Palace, a work that is famous to everyone and for which Agostino remains celebrated.[1]

To reward me for all I had done for him, like

1. No longer extant

* First Secretary to the Grand Duke Francesco, Master of Works to Grand Duke Ferdinando, and Florentine senator

a thorough scoundrel, at the suggestion of one of my very powerful enemies,* he sought, by crooked ways and diabolical means, the acquaintance of my daughter, and having finally seen her, he found the means and the way to introduce himself into my house; and having found the door open, he had the presumption to let himself in, and, reaching the room in which my daughter was painting, he started, by his scheming words and flatteries, to persuade her to love him, by giving her to understand that he was the trusted and beloved servant of their Most Serene Highnesses. Finally, overflowing with deceitful offers, he returned another time to my house and by force and threats dared to have his way with my daughter, and having locked her forcibly in her room and using her for six or seven hours with great violence, he [finally] deflowered her while promising to marry her. And having thus become accustomed to visit our house very often, he occupied himself by continually stoking my daughter's

* Probably Cosimo Quorli, First Papal Steward (responsible for all non-religious furnishings and effects in the papal palace)

Overleaf: Danaë, c. 1612

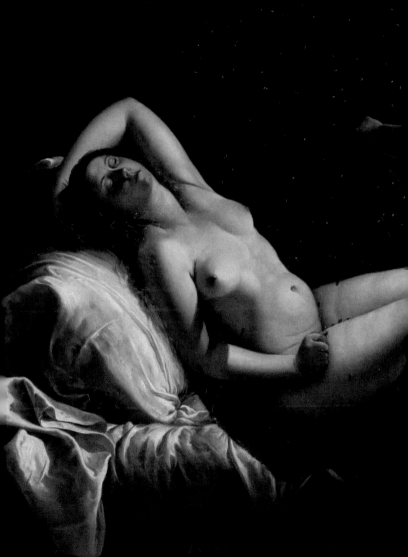

hopes that he would marry her, would take her back to Florence and introduce her to their Most Serene Highnesses, and he told her a thousand other lies of the kind that come easily to such men. When it pleased God, the news reached my daughter's ears that he was married and that his wife had fled him; in short, it was confirmed that this scoundrel had killed her with false promises.

At this moment the traitor finds himself in prison for this rape, and his case has been continuing these last three and a half months. And as I have heard that your Court of Justice [in Florence] has released letters that are very favourable to the cause of this scoundrel, and having learnt elsewhere that the Lord Lorenzo Usimbardi is the source of all his assistance and favours, and trusting in the goodness and mercy of Your Most Serene Highness, I resolved to tell you of this transgression, in the hope that, according to your noble nature, justice be not baffled or suffocated. May Your Most Serene Highness not only order Lord Lorenzo to cease from showing his favour to this degenerate — if indeed it is true that he favours him — but also that you favour me by addressing a letter to the Most Illustrious Lord Cardinal Borghese, asking him to order that in this case justice be correctly executed and that the person

who took the wrong path be punished; and in so do-
ing I assure you that you will be performing a meri-
torious action in the eyes of our blessed Lord God,
for when you see that works and talent of my poor
girl, unique in her profession, I am sure you will be
struck with sorrow at the enormity of the crime done
to me, under the cover of friendship, by the most
degenerate man in the world: as [you may see from
the fact that] he has three sisters who are public pros-
titutes here in Rome, his wife is likewise a prostitute,
his sister-in-law the same, and he himself enjoys her,
one of his brothers was hanged, another brother
banished [from the Papal States] for pimping sodo-
mites, and he himself taken to court in Genoa, in
Pisa, in Leghorn, in Naples and in Lucca, and also
indicted here in Rome for incest, and for robberies
and other obscene things, as can be seen in the cases
in Leghorn, and he is under arrest in Rome as a thief,
as Your Most Serene Highness will be able to see, as
to that end I will send you a report of the two cases,
and I will send you as soon as I can examples of the
work of my daughter, by which you will see some
of her qualities, and by which you will be able to
estimate how much murderous damage has been
done.

Upon which I make a humble bow and I pray to

our Lord to grant you the greatest happiness and a very long life.

From Rome, 13 July 1612

From your Most Serene Highness's
most humble servant and vassal
Orazio Gentileschi,
Painter

To her Most Serene Ladyship Christina
Grand Duchess of Tuscany, my only liege.
By my own hand
At the court where she lies

CRISTOFANO BRONZINI

Biography of Artemisia Gentileschi

c. 1618–19

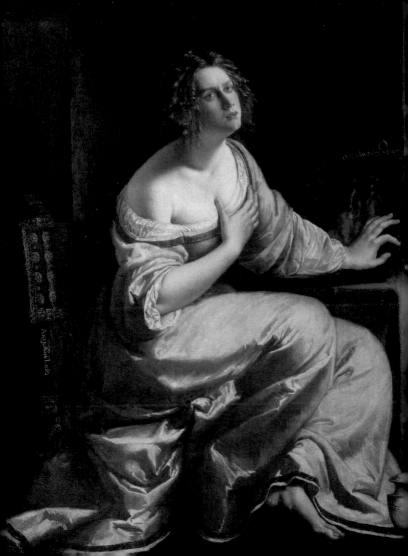

There lives today (and may she live many centuries!) Mizia, of Florentine ancestry but born in Rome, who, one day, when she was about twelve years old, wanted to wear a skirt that her mother had made for her a few years earlier. Finding the skirt now to be by far too short, she decided to lengthen it by herself, and when she did this, she added a little something of her own imagination, adding an embroidery design that she had invented. It happened that this skirt was seen by experts in the realms of design and painting, and they were convinced by what they saw that the young girl had the potential for great achievement in these arts. They spoke with her father and strongly encouraged him to let his daughter study painting, but he would have none of it. Not only did he refuse to teach her, but he also tried to prevent her from becoming an artist by sending her to the convent of Sant'Apollonia in Trastevere for her education. Here in the convent, however, she felt more strongly inclined than ever to become a professional painter, and she begged the abbess to let her study in secret the good painting of a worthy master. The

Opposite: The Penitent Magdalene, c. 1616-17

abbess brought her several paintings, including a *Susanna* by Caravaggio,[1] an artist once judged to be the greatest painter alive. The copies that Artemisia made of these paintings came out so well (especially one of the *Susanna*) that everyone was amazed, and none more so than her own father. When Orazio saw the copies and was assured that they were done by his daughter, he was stunned with disbelief and exceedingly impressed. Still not convinced, he sent his daughter additional paintings to copy, this time quite large ones, all by Caravaggio (whose style she always tried to imitate as the one that pleased her most). After she completed the copies with a masterful finish, some were sold, attaining prices of 300, 500, and even and more, even though these were among her very first paintings.[2] She then married and was brought by her husband to Florence, his native city. The paintings and portraits she made here were as admired no less than the ones made by the above-mentioned Lalla Cizicena,* and they adorned and still adorn the rooms of the most prominent and respected gentlemen, and the halls of the most illustrious and exalted princes living in Florence today.

* A female portrait-painter in Ancient Rome

1. Lost 2. None of these copies has been certainly identified

ARTEMISIA GENTILESCHI

Letter to Cosimo II de' Medici,
Grand Duke of Tuscany

1620

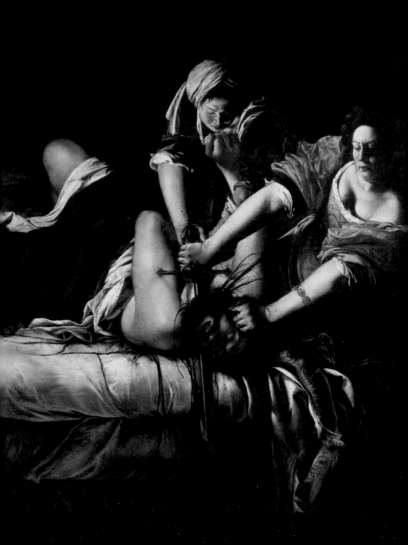

Most Serene Lord
My Lord and Most Worshipful
Master,
So that Your Most Serene High-
ness does not take offense at a short trip that I have
resolved to make to Rome, I wish to let Your Most
Serene Highness know of it by this letter, my journey
being occasioned by the many ailments that I have
suffered, to which many travails have been added af-
fecting my house and my family, such that to remedy
both the one and the other I will stay there for a few
months with my family. During this time, and at the
end of two months at most, I assure Your Most Se-
rene Highness that I will deliver what I owe against
the advance of fifty *scudi* which I received by Your
orders.[1] And while praying God for the perfect hap-
piness and health of Your Most Serene Highness, to
make an end I bow myself down very humbly before

1. This is possibly a reference to *Judith and Holofernes*, Uffizi, Florence,
(ill. opposite).

*Opposite: Judith and Holofernes, c. 1619. This version of the picture ill. p. 170
was made for the Grand Duke and is still in Florence.*

Your Most Serene Highness, and recommend myself with all my heart to Your gracious benevolence.

From my house in Florence, the tenth of February 1620.

Your Most Serene Highness's most humble
and devoted servant,

Artemisia Lomi

ARTEMISIA GENTILESCHI
AND PIERANTONIO STIATTESI

Letters to Francesco Maria Maringhi

March 2–May 17, 1620

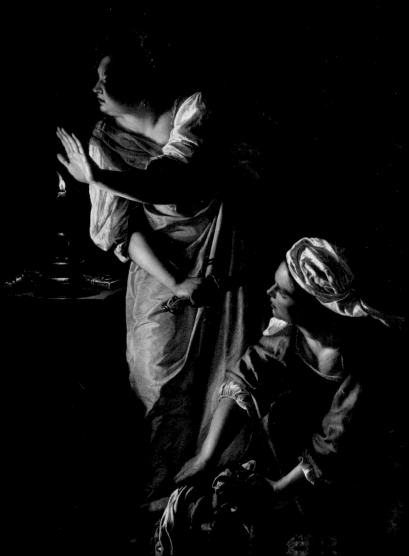

To my Most Illustrious Lord and Most Honoured Master, the Lord Francesco Maria Maringhi, at Florence:

We arrived in Rome safe and sound by the grace of God on Friday night at eleven o'clock; en route we had a great deal of snow; but we got through that quite cheerfully, and since we had decided, while we were still on the road, not to descend on my father-in-law, and have put this intention into effect, we immediately installed ourselves in a house of our own, near the Chiesa Nuova, a beautiful house that we have had put in order this day as modestly as we can. Now we are waiting for our trunk to arrive, and as soon as it does we can complete the picture for the Grand Duke.[1] So Your Lordship should not be anxious, for you will obtain satisfaction and the promise that Artemisia made on your behalf will be kept and you will give the lie to your enemies. So we are waiting here for it to arrive, and will set to bringing it immediately to completion.

1. Presumably the lost *Hercules*

Opposite: Judith and her Maidservant, c. 1623-25

As for our business please do us the kindness of always keeping them before you, until we give other instructions, as we have no desire to occupy ourselves with them. It is not true that Agostino Tassi is in prison; we'll wait to see what happens and will keep you fully informed. She [Artemisia] will finish the paintings and will give satisfaction to everyone, and then she will follow God's will. We are returning to Your Lordship the little cushion, the boot, the purse, the satchels and the spur; and for all these we are infinitely grateful to Your Lordship, and we have no other desire, neither of us, than that Your Lordship give us a commission, since we are under such obligation to you. Of your grace could Your Lordship also let us know about the letter to the Grand Duke and whether it will be answered; and also about what Domenico said on his return from Pisa, and also that cunning devil Migliorati, so that, as soon as the painting arrives, we can get it finished. We would be pleased to hear what is being said in Florence, and what master Pietro Incontri has done on our behalf.* Do us the

* Domenico, a friend, was returning from Pisa where Cosimo II was staying for health reasons. Migliorati was a court official with power over the debts for which Gentileschi and her husband had been indicted; Incontri was an official in the same department

kindness, Your Lordship, to let us know the news, and to forgive all the embarassments, especially the letter addressed to Francesco Francozzi.

I kiss your hands, as does Artemisia, and pray that God fulfils your every wish.

Your Illustrious Lordship's most devoted servant
Pierantonio Stiattesi

ARTEMISIA LOMI TO FRANCESCO MARIA MARINGHI,
ROME, MARCH 5, 1620

Dearly beloved,

If Your Lordship could only imagine the joy I felt on receiving your letter, you would be dumbstruck; only if Your Lordship were transformed into an angel could you possibly understand it. On Tuesday my ruffian of a brother and I came to such a vile exchange of words that if my husband had not been there, he would have had the audacity to slap me in the face. On Friday night he put his hand to his sword, but my husband came between us and might have himself run him through, and the argument was only finished when they were separated, and this is why I did not

Overleaf: Mary Magdalene in Ecstasy, c. 1623

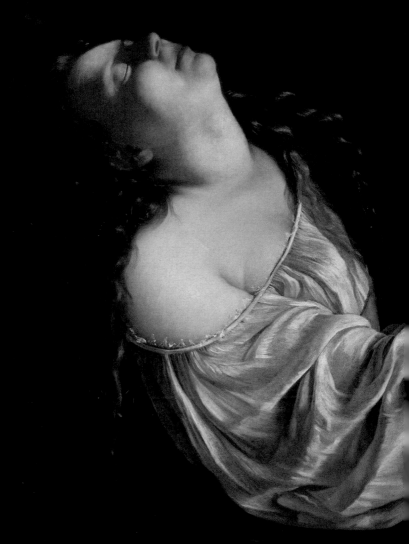

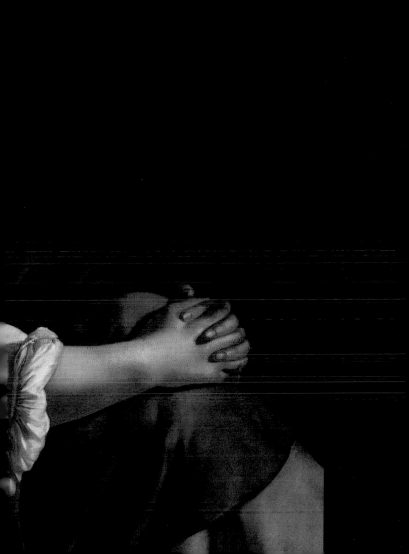

want to stay at their house when we arrived, and I thank God for this and you for turning my thoughts to Him, and I believe that God and the angel whom I worship caused this quarrel now so that I would not have to undergo much worse. Enough; I have come to know my husband better, and everything at the moment is good for me, I have been given many commissions, and I have a beautiful and well-appointed house, and I lack for nothing except your presence. I am eager to know how all my business goes, and please tell me exactly what is happening there and where it is at. I am more delighted than you could ever imagine that you love me, and all the more so that Your Lordship gives me such proof that you love me. Keep yourself well so that I may see you very soon, I am so longing for you to come. Remember me to the thousandth part of how I remember you, I am all yours and remind you of all our promises, all, all of them. My trunk has not yet arrived, but as soon as it does I will realize every debt I owe you. Be as full of cheer as possible. Farewell, my darling love, without you I am nothing, and I kiss those hands I love so much, from Rome the fifth of March 1620

From Your Lordship's most loving
and devoted handmaid
Fortunio Fortuni

PS. Giulio brought me your purse, which was the origin of our quarrel, because it was while I was wearing it that the Princess Savelli helped herself to it; and now her two other sisters have each asked me to get them one, but embroidered; please could you send them for me.

ARTEMISIA LOMI TO FRANCESCO MARIA MARINGHI,
ROME, MARCH 27, 1620

To the Illustrious Lord Fortunio Fortuni, may
God save him, at Florence:
To him whom I so love:
It seems very strange to me that Your Lordship has not written to me; I swear my arms have just dropped to my sides and I am instantly given over to a thousand wild imaginings, but I stopped myself with the thought that all this is the result of the distance between us, or that I am too boring with all the boring worries that I land on you; let us lay the blame on your kindness, and the trust I have always had in you.

But, Your Lordship, love of my life, remember me and command from me whatever you think I am capable of.

I'll make an end here; may God protect you and
keep you in good health, and carry on loving me.
Rome, 27 March 1620
Your Most Illustrious Lordship's
most devoted [servant]
Fortunio Fortuni

PIER ANTONIO STIATTESI TO FRANCESCO MARIA
MARINGHI, ROME, MARCH 27, 1620

To the Most Illustrious Lord Francozzi, may God
protect him, at Florence:
Most Illustrious Lordship and Most Honoured
Master:
By the last two weekly posts I wrote to you at
length, and, with Artemisia's agreement, I have sent
for some of our belongings. However, the fact that we
have not received any letter from Your Lordship leads
us to believe you may not be well, or that you have
not received our letter, for by the last post I sent Your
Lordship the power of attorney, at the same time as
a letter sent by my Lord Mayor of Prato, for which
reason I sent it so that you could produce it in our
defence, and above all that Your Lordship might do
me the favour of finding some means to know when

they will have identified the thief, since I know how many problems that vile and pestilential tongue can produce and will write to you about that in suitable terms. May Your Lordship forgive us all the worries and disputes that we are continuously causing you; and I will put into effect the advice and kind suggestions that Your Lordship has given me on the subject of our friend [Agostino Tassi] who was attacked here in Rome by two men; one of them shot him with an arquebus, which injured him but not fatally; and the second one ran after him with a hatchet to finish him off, but only managed to give him a light wound, almost nothing; so his fate is still in God's hands.

As for the belongings that we sent for, please would you do us the kindness of sending them as soon as possible; and, if possible, at the same time, it would be good if you could include the little piece of porphyry, for we do not at the moment have the means to buy anything. Above all could Your Lordship make every effort to ensure that we receive all the items we ask for in our two letters, because we are in dire need of them. If Your Lordship could arrange a load for a carrier, which will cost you four or five ducats; and here we will make provision to pay him, in case something more is needed for the total cost, and if Your Lordship could send us what seems good to you, but

definitely the baldaquin, the mattresses, the chairs and all the linen [clothes], which we absolutely lack, and also the big quilts, for the interest on our debts is eating us alive, and on top of that the high rent and other expenses are making it difficult for us to cope. And if Your Lordship could come to an arrangement with the old clothes man Giovanni, whereby we might pay so much per month, Artemisia would appreciate it very much, and we are so grateful for all that you will do for us. Send us also the leather hangings, since here one must make a brilliant impression if things are to work, and show that one is not in need, because when people see that a house is well appointed, things go in the right direction and one gains credit thereby. In a few days the Grand Duke's painting will be finished, and we'll send it without delay to Your Lordship, so that you can present it to his Serene Highness, and have fulfilled part of the promise made in our name. I should also inform you that Artemisia's father is angry with her; he has not been to our house for over a week, and has declared that he does not want to enter it again, because Artemisia told him what she thought was right to tell him; and there were hard words between them; however, as I was at home myself, nothing more serious took place, because he was scared what might happen to him. To conclude,

I made him understand that as far as his sons were concerned, I would not meddle in any way; I want to keep them at a distance and consider them to be our enemies, as all my friends have said I should. Enough! I consider it said. Artemisia would like to know news from over there, what is being said and what those famous wagging tongues have got up to. Please would you have the letter to our landlord written up, and the other letters that I sent to Your Lordship, for we need them, since I have to deal with mean people who would tear out her heart and soul. And with these words I kiss your hands and pray God to send you all possible good things.

Rome, 27 March 1620
Your Most Ilustrious Lordship's
most devoted servant,
Pierantonio Stiattesi

Most Illustrious and Most Honourcd Lord,

PS: Artemisia begs Your Lordship to do her the favour of visiting the clothes merchant Master Giovanni and to see if it is possible to come to an arrangement with him so that he can also send us all our leather hangings, for it is necessary in this city to keep one's house in the best possible state. Please could he

send them then, and could Your Lordship arrange that they get to us in as short a time as possible; and I assure you that Artemisia will pay you back, if not for all, at least in part.

This morning — Saturday — Artemisia and I have finally split with Master Orazio her father forever; and she came to some very harsh words, and I entered into the fray as a third, and finally he said to me that he never wanted to set foot in our house again; and I am glad of that, and even more so that all this is over.

Please, Your Lordship, see that everything is done, in every way, to get us what we need, so that we can run our house decently, on the one hand so that my father-in-law shan't believe his eyes, but also to show that while Artemisia was living in Florence, she wasn't a nobody, for my father-in-law believes that she didn't own a bean there. Please could Your Lordship make everything right, especially in regard to the mattresses and chairs, since my desire is that Artemisia should not be insulted by the whole of Rome, like mad dogs. In sum, we have made the split, and I want it to be permanent.

I'm sending the power of attorney for Master Piero Incontri; above all could Your Lordship have the letter written for the landlord (L. Vettori) identifying

those who damaged the chattels, and who put them in hock as they say. I kiss your hands untold times.

Your Most Illustrious Lordship's
most devoted servant
Pierantonio Stiattesi

ARTEMISIA LOMI TO FRANCESCO MARIA MARINGHI,
ROME, APRIL 11, 1620

To his Illustrious Lordship Fortunio Fortuni, may
God preserve him, at Florence:
Comfort of my life:

I have received two letters from Your Lordship, and I am distressed to learn that Your Lordship has on my account suffered great annoyance, and am distressed too to have been able to help in the case only by selling my belongings. I do not know what Love has led me to do, but since I remain here with nothing, I will live like an hermit. I see now that fortune has without a doubt turned her back on me and that she deprives me of everything that can give me pleasure or be useful to me. And to speak the whole truth, consider that God has taken my son from me;

Overleaf: Jael and Sisera, c. 1620

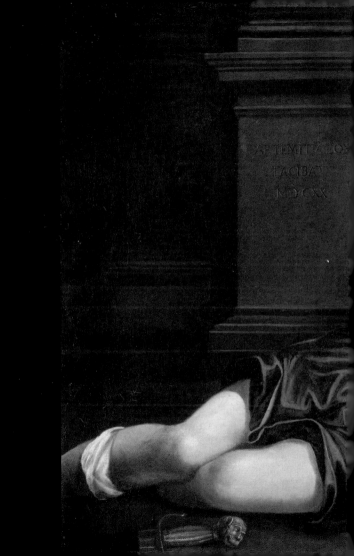

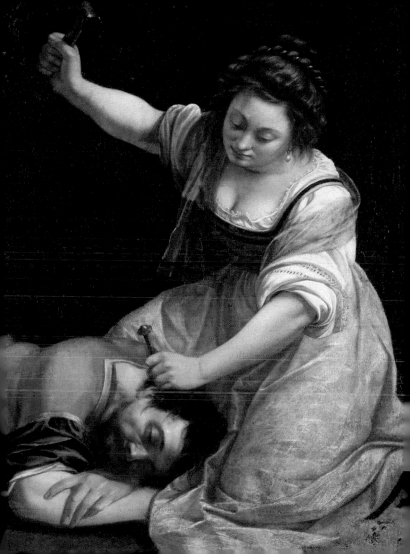

I nearly died of grief; he has already been dead five days. It also seems to me that Your Lordship begins to slacken in the great love you had for me, for you are not perturbed at only having written me the two lines you sent; for if you loved me, your message would be without end. It would be enough to tell me that Your Lordship is more ill than ever. Dear God, if one could see into hearts, one would see such things, and believe me, my Lord Maringhi, my sickness is greater than yours, for the reason that you have confided your sufferings to others. I believe from what you say that Your Lordship has swapped his problems for mine; I wish it were my lot to be able to confide my feelings to my Lord Belerofonte, who would see by how much my sufferings are greater than yours. Suffice it to say that I could not be in a worse case. Your Lordship, who could be my cure, is close to winning my death. Remember her who loves you so. Farewell, fount of my happiness and my unhappiness, who can bring me sorrow or joy.

<div align="right">

At Rome, 11 April 1620
Your Most Illustrious Lordship's
most devoted servant,
Fortunio Fortuni

</div>

ARTEMISIA LOMI TO FRANCESCO MARIA MARINGHI, ROME, SEPTEMBER 2, 1620

To my Most Illustrious Lord, Fortunio Fortuni, may
 God keep him, at Florence:
 My Lord:

 I did not reply to Your Lordship by the last post as I was very busy; I swear I have not had a single hour of respite, for to live in Rome with the reputation that I have won is enough to exhaust a horse; and I have noticed too that there is not the same eagerness to know what is become of me, apart from a certain token of friendship, for which I do thank you. In the end everything comes to an end and so I should not be surprised that there is an end to Your Lordship's love, which I had always reckoned to be infinite. Enough! God keep you.

<div style="text-align:right">

This second day of September
of the year 1620
Your Lordship's affectionate servant,
Artemisia Lomi

</div>

ARTEMISIA LOMI TO FRANCESCO MARIA MARINGHI,
ROME, SEPTEMBER 12, 1620

To the Most Illustrious Lordship Fortunio Fortuni,
 at Florence:
 My Lord:
 I was for a long time angry with Your Lordship,
but then I resolved to make my thoughts clear so that
you could not complain about me; and what I think is
this: you promised me that, as soon as I wrote to you
to come to Rome, you would come, and also that, as
soon as I asked you to send me my belongings, you
would send them all. But I see nothing comes of these
promises; I see you are entirely Spanish, that is to say
your word is gone with the wind, and nothing comes
of it. I will send my husband to fetch my belongings,
and also to take the painting to the Grand Duke, and
thus I will not need to bother Your Lordship, and in
all this I will see the love that you have for me; for if
you truly loved me as you said you did, you would not
have allowed my husband to leave me on my own.
And yet you know what Rome is, not to mention the
relations I have here; you know what my father and
brothers are. Well! I have learnt what I would not
have wished to learn about you; in the end, everyone
looks after themselves: the proof is that while I was in

your Lorship's sight you would do everything possible for me, and the impossible too; but absence puts an end to everything. In conclusion, I will say that if Your Lordship does not come to Rome, and if I do not have my belongings returned to me, I will not hear your name spoken again, and I give you till the end of October to perform this; from then on I will not write to Your Lordship and moreover I will leave this place and you will not know where I have gone; and I will not conduct myself as I have done up till now, acting as if I were a virgin, for I can swear to you that body and soul have been entirely turned towards you. And I believe that even if I had wanted it to be otherwise, I could not have done it, so deep was my love for you. But you have not been the same, traitor. Enough, I will see what is to be done perhaps, everyone for himself. On that note, I'll end. Remember what is written in this letter and believe it to be the Gospel of St John. May God keep you.

This twelfth day of September in the year 1620
Your Lordship's affectionate,
in so far as that is possible,
Artemisia Lomi

POSTSCRIPT:
EXTRACT OF LETTER FROM ANTONIO SELVATICO,
FLORENTINE CORRESPONDENT IN ROME,
TO FRANCESCO MARIA MARINGHI,
ROME, APRIL 5, 1623

To my Most Illustrious and Honourable Lord,

[...] I paid a visit, in the name of Your Lordship, to Madam Artemisia, more beautiful than ever and longing to see Your Lordship more than words can say. I assured her that you would be returning soon, and she charged me to write to you that she is waiting for you and in the meantime kisses your hand a thousand times with the greatest affection that you can imagine. [...]

Rome, 5 April 1623
Your Most Illustrious Lordship's
Most devoted servant,
Antonio Selvatico

ARTEMISIA GENTILESCHI

Letters to Cassiano dal Pozzo

1630–37

I have seen the measurements Your Most Illustrious Lordship has done the favour of sending to me. And I would have served you right away, had I not been obliged to make a few paintings for the Empress,[1] which I must complete by mid-September: that done, my first task will be to serve Your Illustrious Lordship, to whom I am so obliged.

I must beseech you to please do me the favour of sending me six pairs of the finest gloves by courier, for I must make gifts of them to certain ladies. As I do not need anything else at the moment, I bow to you and pray to Our Lord God that He will grant you every happiness. From Naples, August 24, 1630.

Artemisia Gentileschi

NAPLES, DECEMBER 21, 1630

On my return to Naples, having been away for many days in order to paint the portrait of a Duchess,[2] I received the very kind letter from Your Lordship, to

1. Not identified 2. Untraced

Opposite: Portrait of a lady with a fan, c. 1625

which was attached another letter addressed to the Monsignor Nuncio. I now give you the thanks that I would have expressed to you earlier, had I been here when your letter arrived, and beg you to accept my explanation. I do not report news of a success because Monsignor Diego Campanile is seriously ill and his life lies in the balance: this is why the request was not presented.

In order to serve Your Lordship I have used all possible diligence in making my portrait, which I will send to you by the next couriers.[1] I beg you to understand how eager my soul is to serve you and, if all this does not satisfy you, you can at your convenience lash the image of its author, who, shivering still from the cold suffered in doing this work, remains nonetheless confident that Your Lordship's innate courtesy will resolve her misfortune, by sending her gloves and slippers, lest it cause her greater harm.

How much happiness I wish for Your Lordship for this feast of most holy Christmas, and many more to come, I cannot express in this letter, but Your Lordship's good judgment, which I so respect, will easily

1. Untraced

Opposite: Allegory of Painting, c. 1638-39, possibly a portrait of Artemisia's daughter

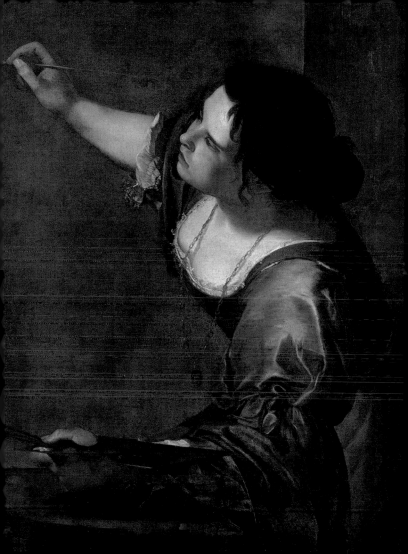

perceive it. With great respect and deep affection, I kiss your hands. Naples, December 21, 1630.

<div align="right">Artemisia Gentileschi</div>

<div align="center">NAPLES, JANUARY 21, 1635</div>

Signor Francesco, my brother, comes to your house to accompany one of my paintings and to give it in my name to the Most Eminent Lord Cardinal Don Antonio, if he finds it to his liking.[1] However, as in these parts I have no protector other than Your Lordship, whom I have always entrusted with all my concerns, it is to you that I turn so that you might apply all your effort in a matter that regards me. I beg you earnestly to introduce my brother to His Eminence and to arrange things there so that he might be quickly dispatched, since I have a great need of my brother, given that he is in charge of all my affairs.

This is why it is imperative that you urge His Eminence to bring the matter to a successful conclusion, since the pressing situation in which I find myself means my brother cannot stay in Rome for more than

1. Possibly *Venus and Cupid*, Virginia Museum of Fine Arts, (ill. pp. 12-13)

four days. May Your Lordship therefore make use of your influence in this concern of mine and oversee it, as you have always done on other occasions concerning me, so that my brother and I, through your intervention, may be successful in the matter. For all this, we will remain forever very obliged to you for your courtesy, to which I am indebted so many times over.

And now, while I pay you due reverence, I affectionately kiss your hands. Naples, January 21, 1635.

Artemisia Gentileschi

NAPLES, NOVEMBER 24, 1637

In the previous letter I wrote to Your Lordship, I pointed out that the paintings I was ready to send were twelve *palmi* high and *nine* palmi wide,* but I did not discuss the subject. I will tell you now that the subject is the Samaritan woman with the Messiah and his twelve Apostles, with landscape views both near and far etc., embellished with great finesse,[1] and another,

* 317 x 238 cm; a Neapolitan *palmo* equals 26.4 cm.

1. Private collection, Naples

Overleaf: Nativity of St John the Baptist, 1633-35

representing St John the Baptist in the desert, measuring nine *palmi* in height and having a proportionate width.[1]

This is what I can tell Your Lordship on this topic. It is now up to you to do as best you can, which I beg of you, in order to help me, so that through your efforts I might soon experience the benefit and relief of arranging a good marriage for my daughter as soon as possible, and, once that is resolved, come there, as I have already mentioned to you, to enjoy my fatherland and serve my friends and masters.

I end this by affectionately kissing the hands of Your Lordship and praying to Heaven to grant you every happy success. Naples, November 24, 1637.

 Artemisia Gentileschi

1. Untraced

ARTEMISIA GENTILESCHI

Letter to Galileo Galilei

1635

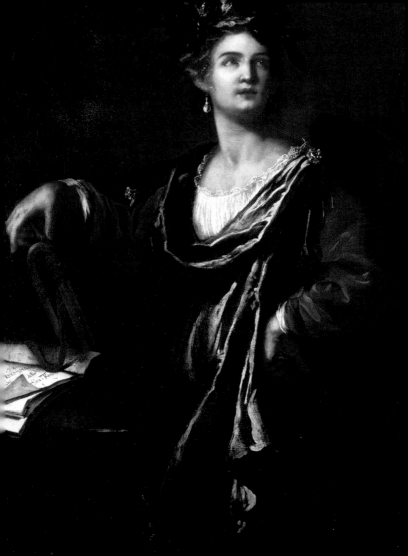

My very Illustrious Lord and most Honoured Master,

I know that Your Lordship will say that if I had never had the need to avail myself of his favour, I would never think of writing to him; and in truth, given the innumerable obligations I have towards you, you would think it an infallible argument since you do not know how many times I have tried to learn news about you, when no one could give me reliable information.

But now that I know that you are there [in Florence] and situated very well, thank God, having no other recourse I turn to you, whom I can count on to assist me in every way, and in no other Lord do I put my hopes. And I do so all the more willingly as a situation has arisen that is similar to the one concerning the painting of Judith[1] that I gave to Grand Duke Cosimo, may he rest in peace, and which the court would have forgotten had Your Lordship not

1. Probably *Judith and Holofernes*, Uffizi, Florence (ill. p. 78)

Opposite: Clio, the Muse of History, 1632

intervened to revive the matter, and thanks to you I obtained a very large compensation.

So I ask you to do the same now that I still have not heard anything in response to the two large paintings that I recently sent to His Most Serene Highness through one of my brothers.[1] I don't know if he appreciated them; I only know from a third party that the Grand Duke received them, and nothing else, which caused me to feel greatly mortified, since I am accustomed to finding myself honoured by all the kings and grandees of Europe to whom I have sent my works, not only with their very large gifts, but also with their exceedingly laudatory letters which I keep with me.

Recently, the Lord Duke of Guise, [Charles of Lorraine] as a reward for one of my paintings that was presented to him by my same brother[2] handed him 200 piastres to give to me — but which I never received because they went elsewhere — whereas from His Most Serene Highness, my natural Prince [i.e. Ferdinando II], I have not received any thanks. Now I assure Your Lordship that I would have esteemed the least of your favours more than all those

1. Unidentified 2. Unidentified

I have received from the King of France, the King of Spain, the King of England, and all the other Princes of Europe, in view of my desire to serve you and to return to my fatherland [Florence], also in view of the loyalty that I had shown to the Father of His Most Serene [Highness] for so many years.

The magnitude of His Most Serene Highness's generosity, to which to all talented men make recourse, is already well known. Therefore, why should there be any surprise if I, who can be counted among them, should have resolved to give some of the fruits of my labour to him — indeed, I more than anyone else owed him this debt both as a vassal and and as a servant. I cannot believe that I have not brought satisfaction to His Most Serene Highness when I satisfied my debt.

This is why I hope that Your Lordship will discover the truth, indicating to me all that concerns the Prince in this matter: it will bring relief to the displeasure I feel, since my great devotion has met with such utter silence.

For this reason you would be doing me such a great favour that I would value it above any other favour

Overleaf: Death of Cleopatra, 1635

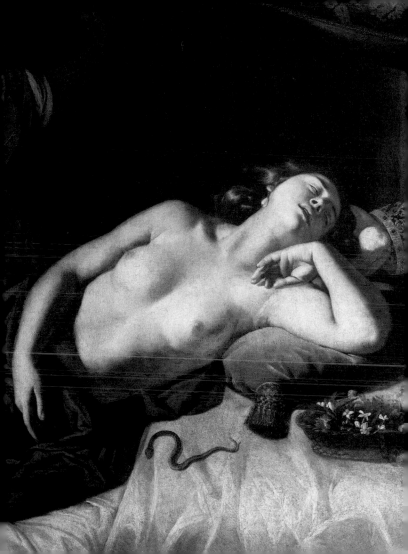

that I have received from Your Lordship; whose hands I kiss a thousand times, assuring you that I am your grateful servant forever, and I bow to you deeply. From Naples, [20] October 1635.

From Your very Illustrious Lordship's
very devoted servant,
Artimitia [sic] Gentileschi

If Your Lordship would be so kind as to write to me under the cover of Lord Francesco Maria Maringhi.

ARTEMISIA GENTILESCHI

Letter to Andrea Cioli,
Secretary to the Grand Duke of Tuscany

1636

Most illustrious Lord,

After hearing that Your Lordship had fallen ill, I felt so much sorrow that from then on I kept urging all those close to me to pray to God: thanks be to Almighty God, I heard the news that you are doing a little better, thanks be to our Lord.

I inform Your Illustrious Lordship that if I can adhere to my goals, I hope that it will not be from other hands that you receive my future letters, but that I myself will be their bearer; and if you want me to send you the picture, or bring it to you myself, let me know, because since I wrote to you it has been ready for delivery.

And if there should be an opportunity for me to meet His Most Serene Highness, I beg you not to forget what I alluded to in the last letter I wrote to you, because I have no desire to remain in Naples, as much because of the chaos of war as for the hard life there and the high prices.

Deign to do me the favour of your kind answer, for I could not desire anything else in this life; I pray

Opposite: The Annunciation, 1630

to Heaven to grant you all kinds of benefits. From Naples, February 11, 1636.

<div style="text-align: center;">

From Your Very Illustrious Lordship's

very devoted servant,

Artemisia Gentileschi

</div>

ARTEMISIA GENTILESCHI

Letter to Francesco d'Este,
Duke of Modena

1639

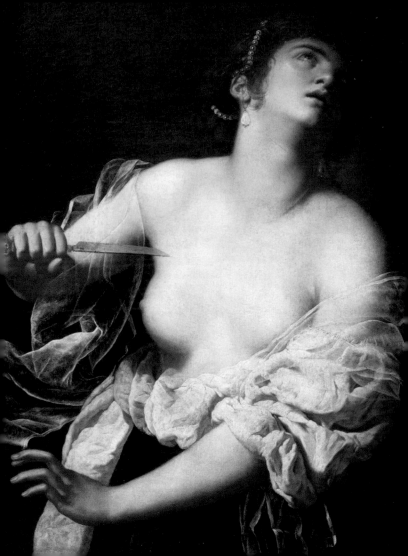

Most Serene Highness,

Great Princes, like Your Most Serene Highness, serve as a stimulus for spirits thirsting for glory to progress as much as possible in their talents, in order to dedicate their efforts to [these princes] and then to achieve the noble goal to which they aspire. This is precisely the case with me, and not content to have arrived at the service of the Crown of England, from which I receive very singular honours and favours, I find I cannot satisfy my ambitious hopes, except by sending you by means of my other brother, (who has been sent by the Her Majesty the Queen, my mistress and his, to look after her affairs in Italy), this little fruit of my labour that has not been dressed with any perfection, but is rich in the deep reverence that I bear towards you.[1] I therefore beg you with devout humility to excuse its imperfection, due to my natural inexperience, in spite of which my works have always been appreciated by

1. Unidentified

Opposite: Lucretia, 1630-40

all the greatest Princes of Europe and, in particular, by Your Most Serene Highness who, with demonstrations of generosity, has splendidly honoured them on previous occasions. I did not take this decision without the consent of Her Majesty and that of the Queen Mother, my mistress, which makes me hopeful that Your Highness will not disdain it, or better yet, I dare to believe that you will approve of it and, should that come to pass, I would see it as the fulfillment of all I desire.

And with devoted zeal I pray to our Lord God to grant a happy outcome to all the heroic projects of Your Most Serene Highness.

<div align="right">

From London, December 16, 1639
From Your Most Serene Highness's
most humble and devoted servant
Artimitia [sic] Gentileschi

</div>

ARTEMISIA GENTILESCHI

Letters to Don Antonio Ruffo

1649–51

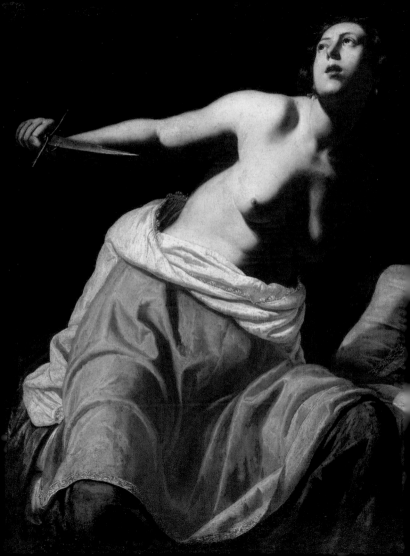

My Most Illustrious Lord and Master,
 By God's grace, the painting[1] has reached Your Most Illustrious Lordship, who, I believe, by this hour will have already seen it, and I believe that as long as you have not seen the painting, you will have considered me arrogant and impertinent. But I trust Our Lord God and hope that by seeing it, you will think that I was not entirely wrong; indeed, if [the painting] were not intended for Your Illustrious Lordship, whom I serve with such affection, I would not have agreed to cede it for these 160 [ducats], because in all the regions where I have been, I was remunerated one hundred *scudi* for each figure, in Florence, in Venice and in Rome, and in Naples, too, when there was more money around. Whether this should be considered the merit or the good fortune of Your Most Illustrious Lordship, as a knight of great discretion and endowed with all the world's virtues, [Your Lordship] will be the judge of what I am worth. I strongly sympathize

1. Possibly the *Triumph of Galatea*, (painted with collaboration),
c. 1649, private collection (ill. overleaf)

Opposite: Lucretia, c. 1635-50, in collaboration with Onofrio Palumbo

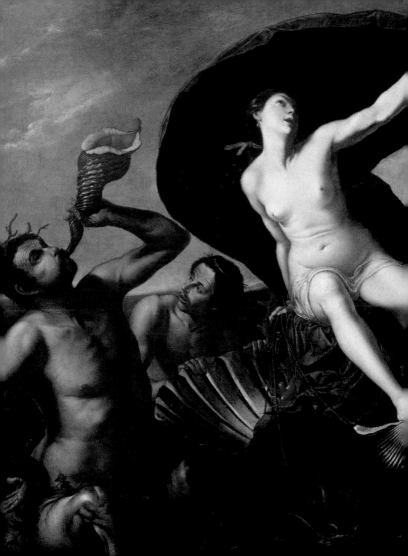

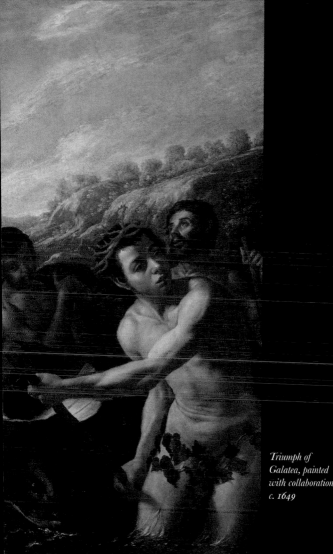

Triumph of
Galatea, painted
with collaboration
c. 1649

with your Lordship because hearing a woman's name leaves one in doubt, until the work is seen. Forgive me, for the love of God, if I have given you cause for regarding me as self-interested; in fact, I will not bother you anymore: I will only tell you that on future occasions I will serve you greater perfection. And if Your Lordship likes my work, I will also send you my portrait,[1] so that you keep it in your gallery, as do all the other Princes. And with that I end, and I make a very humble curtsey to Your Illustrious Lordship, assuring you that as long as I live, I will be ready to answer all your commands and in closing I kiss your hands. Naples, January 30, 1649.

<div style="text-align:center">

From Your Most Illustrious Lordship's
most humble servant,
Artemisia Gentileschi

</div>

<div style="text-align:center">

NAPLES, JUNE 5, 1649

</div>

My Most Illustrious and Most Honoured Sir,

I received the magnanimous letter of Your Most Illustrious Lordship, dated the 24th of last month, with the spirit of obedience that my numerous obligations

1. Untraced

to you require, which increase daily due to the excess of benevolent favours that the courtesy of Your Most Illustrious Lordship extends to me. You must know that the painting[1] is more than half completed, and it is hoped that it will succeed in bringing you every satisfaction; but because of the indisposition of the person who serves as my model, it is not at present quite finished. Regarding my portrait, which Your Most Illustrious Lordship desires despite my meagre merit, it will be sent along with the painting. In the meantime, I consider myself very obliged for the trouble to which you have so kindly gone in seeking some commissions for me, [which], because of the austerity of these times, are very rare. The Lord Prior* daily honours me with singular favours, and I have painted three pictures for him, which he liked very much.[2] Nothing else occurs to me now. After making a very humble reverence to Your Serene Lordship, I pray that the Divine Majesty will grant you all the prosperity that you deserve and desire. Naples, June 5, 1649.

From Your Most Illustrious Lordship's
very devoted and very obliged servant,
Artemisia Gentileschi

* Don Fabrizio Ruffo, nephew of Don Antonio

1. *The Bath of Diana*, untraced 2. Untraced

NAPLES, JUNE 12, 1649

My Most Illustrious Lord,

Last week I replied to one of your letters, which I had received from the hands of Lord Don Pietro;* now, I find myself constrained by two circumstances. First, I must quickly finish your painting; and secondly, I do not have the money to finish it. I beg Your Most Illustrious Lordship, insofar as I am your servant, to write me a bill of exchange of fifty ducats, and as soon it arrives, I will complete the picture, because the expenses are great, owing to the need to employ these naked women. Believe me, Lord Don Antonio, the cost is unbearable, because if I pay to undress fifty, I can hardly find one that is suitable. For this painting I cannot confine myself a single model, because it has eight figures, and it is necessary to show various kinds of beauty. I am bold in begging my master to grant this request. Forgive my boldness, and I kiss your hands in reverence. This day, June 12, 1649.

From Your Most Illustrious Lordship's
very humble and very devoted servant,
Artemisia Gentileschi

* Don Pietro Ruffo, brother of Don Antonio

Opposite: Bathsheba at her bath, c. 1645

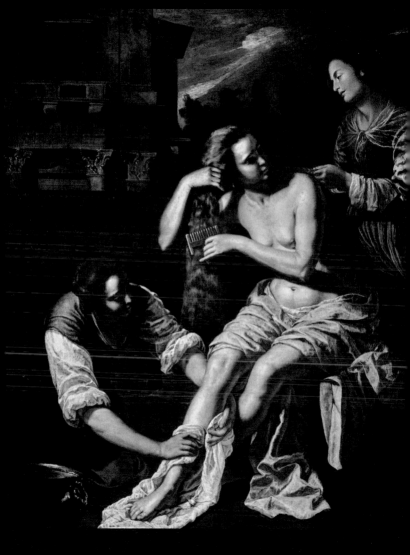

Do not be surprised at the changes of hand you seen in the writing, for I dictate my letters while I paint, and when you see the writing of my signature [...], you can be assured that it is mine.

NAPLES, JULY 24, 1649

Most Illustrious Lord,

I have received your very kind letter, as well as your bill of exchange, and I thank you very much for your diligence, because I see that Your Illustrious Lordship is spoiling me. As for the question of completing the picture by the tenth of this month, that is impossible for me, because this picture requires three times the work involved in the Galatea. I working on it continuously and with alacrity; however, I don't want this to compromise the perfection of my painting. By the end of August, I believe it will be finished.

I would like to know what happened to Titta Colimodio, because it has been a long time since I had any response to the letters I sent her.* Can your Lordship do me the favour of communicating to her

* Nothing is known about this person.

that she should write to me because I need to corre-spond with her about something of great importance? I beg you to encourage her to write to me as soon as possible.

And here I end by kissing your hands and wishing you every happiness. This day, July 24, 1649.

<div align="right">Your servant,
Artemisia Gentileschi</div>

My portrait will be sent with the painting.

NAPLES, AUGUST 7, 1649

Most Illustrious Sir and My Most Honoured Master,

At the same time as the very kind missive from Your Most Illustrious Lordship, I received the bill of exchange for cash, which was paid to me immediately, and I thank you very much for this; now I must tell you that the painting is well on the way to completion and that by the end of this month it will be finished: eight figures and two dogs, which I hold in greater esteem than the figures; and I will show Your Most Illustrious Lordship what a woman knows how to do, hoping to give you great pleasure.

Moreover, I await good news of the health of Your Most Illustrious Lordship, as well as the honour of

receiving your orders; in the meantime, I affection-ately kiss your hands and bow to you, as well as to my Lady your wife. Naples, August 7, 1649.

> From the most devoted and most grateful
> servant of Your Most Illustrious Lordship,
> Artemisia Gentileschi

NAPLES, SEPTEMBER 4, 1649

Most Illustrious Sir and Very Honoured Master,

Your Most Illustrious Lordship will find strange this delay with my painting, but to serve your interests the very best way I can, as I am obliged to do, when painting the landscape and laying down the lines of perspective, I had to redo two figures, which I am sure will bring great pleasure and satisfaction to Your Most Illustrious Lordship; and I beg you to pardon me but due to the tremendous heat and my numerous ail-ments, I have to pace myself and work little by little, assuring you that my delays are to the great benefit of the painting and will bring particular satisfaction to Your Most Illustrious Lordship, to whom I bow and remember myself. Naples, September 4, 1649.

> Your very devoted and obliged servant,
> Artemisia Gentileschi

NAPLES, NOVEMBER 13, 1649

My Most Illustrious Lord,

I received a letter on the 26th of the last month, which gave me the greatest pleasure, seeing how my Master is always ready and willing to favour me, although I do not deserve it; and from that letter I have heard your thoughts on this Cavalier who wishes to have paintings from my hand, and wants a Galatea[1] and a Judgment of Paris.[2] In truth there was no need to urge me to render this Galatea differently from that of Your Most Illustrious Lordship because, by the grace of God and of the Most Glorious Virgin, [your words] are addressed to a woman who abounds in this merit, that is, the variation the subjects of my painting; and no one will ever have found in my paintings a repeated invention, even in the case of a simple hand.

As for the price that this gentleman asks for even before the work is carried out, believe me, as I am your servant, he does not realize that even while he believes he is acting correctly, he is instead doubting my good conscience, which I value more than all the gold in the world. I know how much by my mistakes

1. Possibly the *Galatea* in the National Gallery of Art, Washington, DC 2. Untraced

I can offend our Lord God, and I know and I fear that we are not always inspired by the grace of our Lord; that is why I never estimate the value of my works until they are completed. But since it pleases Your Illustrious Lordship that it be done as you have commanded, please tell this gentleman that he can show [the pictures] to everyone, and that if he finds that the aforesaid paintings are not worth and not valued at two hundred more crowns more [than the price I ask], then I do not want him to pay me at all. The contract [is] concluded, and I assure Your Illustrious Lordship that these are paintings which include female nude figures, which are very expensive and the source of headaches; and when on occasion there is something good there, they fleece me coming and going, and sometimes you have to endure their pettiness with the patience of Job.

As for wanting me to make sketches and send them, I have resolutely vowed never to send more sketches by my own hand, because I have been the victim of very nasty tricks; and in particular because today I discovered that, having made a sketch of the souls in Purgatory[1] for the Bishop of Sant'Agata, and to save money, they are going to have this [altarpiece] carried

1. Untraced

out by another painter, a painter who reaps the profits of my labour. If I had been a man, I do not doubt this would ever have happened, because once the original composition has been worked out and established with shade and highlight and organized into the different planes, all the rest is smooth sailing. This is why it seems to me that this Cavalier is very wrong to seek sketches, since he knows the design and the composition of the Galatea.

I could not add anything else, except that I kiss the hands of Your Most Illustrious Lordship and I make you a very humble reverence, asking Heaven to grant you the greatest happiness. This day in Naples, November 13, 1649.

<div style="text-align:center">From Your Most Illustrious Lordship's
most humble servant,
Artemisia Gentileschi</div>

Let it be known, Your Most Illustrious Lordship, that, when I ask for a certain price, I do not do it following the custom in Naples, where one asks for thirty crowns to receive four. I am Roman, I always do business in the Roman way.

NAPLES, NOVEMBER 13, 1649

My Most Illustrious Lord,

I do not think it appropriate to discuss our interests in this letter, in case by any chance our Cavalier manages to read it, I will therefore say to Your Most Illustrious Lordship that in regard to the paintings for which you seek a bit of a discount on the price that I have given, they cannot be had for less than four hundred ducats, and I am to be given a deposit for them in accordance with the custom of gentlemen. But I must clarify that the higher the price, the harder I will endeavour to make a painting that is to the liking of Your Lordship, and conformable to my taste and yours. Regarding the painting for Your Most Illustrious Lordship, which is already finished, I cannot give it to you for less than what I asked for, because I have done my utmost to give you absolutely the lowest price possible, and I swear to you, as your servant, that the price that I gave you I would not have given even to my own father. Lord Don Antonio, my master, I beg you for the love of God not to hold against me what I have said to you, for I am sure that when you see it you will say that I was not impertinent. And even the Lord Duke, your nephew, agrees that I show great affection to Your Most Illustrious Lordship in light of

the prices that I give you. I will only remind you that there are eight [figures] and two dogs, landscapes and waters, and Your Most Illustrious Lordship will see that it entails an outrageous expenditure for models.

I will not say anything else except that which I keep always in my thoughts, namely that Your Most Illustrious Lordship will not come out the loser with me, and that you will discover the spirit of Cæsar in the soul of a woman. Thereupon I pay you a very humble reverence. From Naples, November 13, 1649.

Your Most Illustrious Lordship's
most humble servant,
Artemisia Gentileschi

NAPLES, AUGUST 13, 1650

Most Illustrious Lord and Most Honoured Master,

The fact of having received letters from Your Most Reverered Lordship, which I had so desired, and of having your commissions to me renewed in them, gives me to understand that you have not totally forgotten me. This makes me hope that in the future, too, you will favour me by honouring me with commissions, as a result of which you will feel, on their completion, that I devote my life to your service,

which I wish to prove as soon as possible with this little Madonna,[1] assuring you that, if in the past you have liked my large-scale works, these small ones will please you no less, which I hope to show you shortly while awaiting more frequent orders from Your Most Illustrious Lordship, whose hands, for as long as you accord me this honour, I will kiss with all my affection. Naples, August 13, 1650.

> The very affectionate servant of Your Most
> Illustrious Lordship, Lord Antonio Ruffo,
> Artemisia Gentileschi

NAPLES, JANUARY 1, 1651

Most Illustrious and very honoured Lord and Master,

It is already a month since I wrote to Your Illustrious Lordship and sent you my best wishes, rejoicing in the recovery of your health; but I was not worthy to receive your answer. I fear that my letters were sent via a person who was not very kind to me, because there were three of them, addressed to different people; but not one of them has answered me. I would like to know by sending this one if indeed Your Most

1. Untraced

148

Illustrious Lordship received my letter. I spent this last Christmas in bed, as I was very sick, and now I am still recovering. Your little painting on copper is more than half done, and as soon as I can paint, it will be my first priority.[1] I had let it be known in that previous letter to Your Most Illustrious Lordship that in my possession were two paintings of the same size as the Galatea: they are half finished and represented in one is Andromeda when she was set free by a knight who, while flying in the air on the horse Pegasus, kills the monster who wanted to devour that woman, and between them is a very beautiful landscape and a very beautiful seascape.[2] In short, it is a superb picture. The other tells the story of Joseph, whom the wife of Potiphar tries to force, with a very beautiful canopy bed and a paved floor with a very fine perspective.[3] I wanted to offer them to Your Most Illustrious Lordship for a low price. The many ailments and travails that I suffered this past year having forced me to cast them off, it would please me if you were to enjoy them, in reflection of my esteem for Your Most Illustrious Lordship. To lighten my burdens, it is necessary that you do me the favour of paying me an advance of one hundred ducats, and I will deliver the

1. Untraced 2. Untraced 3. Untraced

paintings to Your Illustrious Lordship only for ninety ducats each as long as Your Most Illustrious Lordship does me the favour of paying me a hundred crowns in advance. I will ensure that in April, and even before, that you will receive these pictures. But I beg you, if you will do me this favour, let it be immediately, for the aforesaid hundred crowns are needed for a thousand things. And I finish by begging you to grant me a prompt answer so that I can look forward to getting better. Offering myself to you with great devotion and gratitude, always at the command of Your Illustrious Lordship, declaring myself forever devoted and obliged. Naples, January 1, 1651.

From Your Most Illustrious Lordship's
very devoted servant,
Artemisia Gentileschi

FILIPPO BALDINUCCI

Life of Artemisia Gentileschi

c. 1682

There stayed in this region of ours [i.e. Florence] a daughter of Orazio Gentileschi [who was] extremely beautiful in appearance, and as skilful a painter as I have ever found among other women, who was made the spouse of a certain Pierantonio Schiattesi [sic]. This one [Artemisia], who had learned the art [of painting] from her father, first devoted herself to making portraits, of which she made very many in Rome. And her brush was much employed in the city of Florence, and other places. For Michelangelo Buonarroti the Younger, celebrated intellectual and poet, that man who composed the beautiful rustic comedy called *La Tancia*, this virtuous lady painted in an extremely beautiful manner a life-size figure, namely a woman of extremely beautiful, very lively and proud appearance.[1] She grips a compass, and while a shining star, almost like a guide, shines over her forehead, she has at her feet two small pulleys, to demonstrate, I believe, her quickness and facility in moving, and meanwhile, acquiring every more noble ability. This figure, that was made to represent *Inclination*, had a place on the ceiling, in the fifth small space above the

1. Still in situ, Casa Buonarroti, Florence (ill. p. 153)

Opposite: Portrait of a man, probably Antoine de Ville, c. 1626-27

door through which one entered into that room. This was an extremely noble room of the house, which, among the others of his [i.e. Michelangelo Buonarroti the Younger's] beautiful gallery, was dedicated to the glorious actions of the great Michelangelo Buonarroti his ancestor. This figure was totally nude, and this was according to the poetic conceit of Buonarroti, but Leonardo, his nephew and heir, a gentleman also of rare qualities, because of the decorum and modesty with which he wanted every place in his own home appear to be adorned for the chaste eyes of a beautiful multitude of little boys who were his sons, and of the noble Ginevra d'Esau Martellini his wife, wanted the nudity covered up by Baldassarre Volterrano, [whose name was suggested] by him who writes this. Volterrano did this up to the point that the pious feelings of Leonardo were satisfied without taking away any of the beauty of the painting.

In the home of the noble Florentine, Giovanni Luigi Arrighetti, is a beautiful painting by the hand of Artemisia, in which she represented Aurora a little less than life-size.[1] A pretty nude female with loose

1. Still in situ, Casa Buonarroti, Florence

Opposite: Allegory of Inclination, 1615

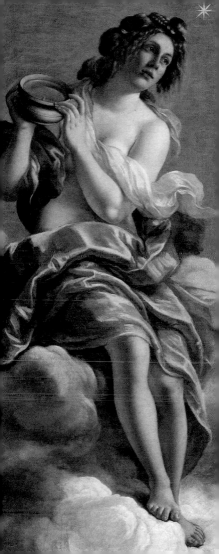

hair, and stretching her arms towards the sky, she is in the act of rising from the horizon, in which one sees the first light appear, and is coming to sweep away what remains the dark haze of night. The front of the figure is gracefully shaded in a manner that does not, however, prevent the beautiful proportion of the limbs, and the pretty complexion, from showing, remaining only struck by the rising morning light from the opposite side. And truly it is a beautiful work, which makes one recognise to what a high level the talent and the skill of such a lady reached. In the palace [i.e. of the Medici] are two paintings by the hand of Artemisia, in one of which, of a fairly large [size], is represented the Abduction of Proserpina with a great number of figures made in very good taste.[1] But the other painting [with] life-size figures in that palace, which people say is also by her hand, is extremely beautiful, in which is painted a Judith in the very act of cutting off the head of Holofernes from his torso, a work that certainly surpasses every other from her hand in quality, and is so well thought out, and so naturally expressed, that just looking at it thus painted makes one not a little terrified.[2]

1. Lost 2. Uffizi, Florence (ill. p. 78)

Opposite: Aurora, 1625-27

She had another beautiful skill, which was to portray marvellously, in a naturalistic manner, every kind of fruit, and I do not wish to neglect to tell that which I have learned among many trustworthy reports that have come to me from the city of Rome, in order to give an account of the good painter Giovanni Francesco Romanelli from Viterbo, the student of Cortona.

This artist was very much employed in that city [of Rome] in the time of Urban VIII, and in much favour with the Barberini household, and because he was a lively young man, and a good friend of gallantry, he had formed a virtuous friendship with the painter Artemisia. Finding himself frequently in her home for the pleasure that he took in seeing her paint, and entertaining her in extremely pleasant discourses on art, he wanted to make a portrait of her. It was precisely at that time in which she gave great example of herself in the extremely beautiful paintings of fruit that issues from her brush, wherefore Romanelli commissioned her to make a picture all filled with this type of painting, leaving enough space to allow an opportune place, in which to beautifully display the portrait of the painter [i.e. Artemisia] precisely in the act of painting, with this portrait being made by his [i.e. Romanelli's] own hand. Artemisia obeyed him,

and the painter in a most gentle manner made the beautiful portrait of her, not for her, but for himself, and he considered it so dear, that later upon returning to his homeland, he wished to cary it with him, just like every other more costly household furnishing, of which he had many thanks to the numerous gifts he had from prelates and lords in Rome.

He showed it to his wife, and then gave it a well-arranged place among the other beautiful paintings with which he adorned his own home, and some-times in jest he called his wife, and made her consider the portrait of Artemisia. And he set himself no less to the praises of her mother, who had made her so beautiful, than to [praising] the beauty of the young woman and the bizarre artifice with which she had painted the fruit; amplifying besides this what the painting could not demonstrate, I say, the beauty of her gentle features, the gracious speech, the witty conceits, and her other similar qualities. He did all this to take amusement of the outrage of his wife, who also was very beautiful, and who, frequently fuming on account of excessive jealousy, finally became so angry one day that, seizing the time in which her husband was not at home, [she] equipped herself with a large hairpin, or bodkin, or awl, and began to go about frequently piercing [the portrait], especially the face of

that so much disliked Artemisia, and particularly those places whose qualities received the most praise from her husband; who noticing that gentle vendetta, and taking into account his dear wife's well-founded love towards him, desisted entirely from praising any more that portrait, which while I write this piece, I think is still found in the house of Romanelli's heirs.[1] Further information concerning the person or the works of Artemisia has not reached us, other than that, finally taking herself to Naples between 1630 and 1640, she was still living there in 1642, working for the princes and lords of the city with great glory and profit.

1. Now lost

AVERARDO DE' MEDICI

Memorial of Artemisia Gentileschi

1792

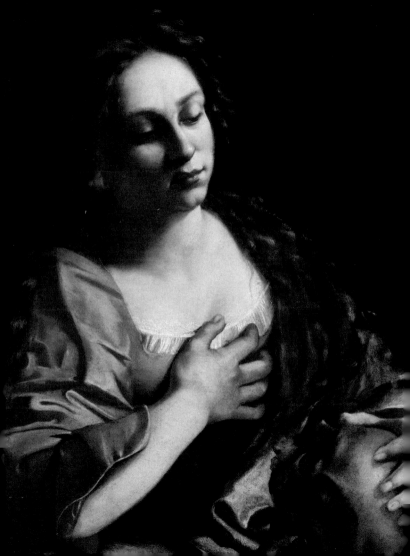

He errs whosoever believes that women (by reason of being the weak sex) are not susceptible to those bold notions that drive the soul to undertake grand endeavours, when instead we are convinced by a long series of demonstrations that women have attained excellence in all of the arts to which they have directed their efforts; and there is no field so challenging, or literature so extensive, as to hinder many of them from achieving complete mastery on a par with men. In fact, considering that Nature has given women more delicate faculties for forming the imagination, and hence the most vibrant images — these being the fountainhead and most necessary gift for the Fine Arts — I consider women, more so than men, were created by Nature for the study and perfection of the arts, and in particular painting and poetry, for which their capacities provide both the substance and the ornament.

Pisa, fecund mother of illustrious men, vaunts her heroines too, and destined for eternal fame is the name of Artemisia Gentileschi, a female painter of the highest acclaim, the composition of whose *Memorial* I undertake at the request of a distinguished individual held in exceptional merit by his native land,

Opposite: Magdalene with Skull, c. 1631

and also due to the esteem which I justifiably accord to the valiant Sons of Alfea [i.e. Pisans]. And thus the reader should not marvel that I, although of a different profession and nationality, have accepted this most honourable charge, and all the more because glorious deeds have the advantage of being admired even from afar, and of provoking praises from anyone.

Artemisia belonged to the Lomi family, which has embellished its homeland with a series of distinguished artists admired throughout the sixteenth and seventeenth centuries, including Giambattista, the goldsmith and father of both Aurelio and Orazio. The latter were eminent painters and students of Baccio, their paternal uncle who was also a painter and whose works in fresco and oil paint are in Pisa, the city where Artemisia was born in the year 1590.

Timarete, the daughter and disciple of the painter Micon, Irene likewise of Kratinos, Aristarete of Nearchos, Faustina the daughter of Carlo Maratta, the daughters of Mengs and of Batoni, and a hundred other bright lights in the History of Painting demonstrate to us how much power Nature has in her secret imprints, and how the hidden disposition towards beautiful things is passed down through the blood from father to offspring, especially when an education is added to this so as to perfect the results. In the

same way, Artemisia received through her birth the same gifts for painting, passed down from her father and from her ancestors, who also gave her an exceptional training; thus we should not be surprised that she managed to equal them, and perhaps even to surpass them. And just as the stability of a building permits us to infer the soundness of its foundations, we might well believe that the teachings she received from her father and uncle were superior and that she applied herself indefatigably to her studies. This is all the more the case because we know that among these illustrious family members, Orazio was by far the best; and thus breaking away from the manner of his uncle and his brother by means of his judicious appreciation of the works by the principal Roman masters and others, he reached such heights of excellence that his paintings were regarded as the crown jewels and ornaments of the most discriminating galleries of Europe, ranking alongside those of the most renowned artists.*

* Orazio Lomi Gentileschi not only holds distinction among the artists of his family, but he also can lay claim to being among the most skilled masters of his era, as witnessed both by his artworks and by the opinions of the most discriminating biographers and critics of the arts (Soprani, Baglioni, Sandrart, Baldinucci, Orlandi, and the editors of the *Serie d'Uomini Illustri nelle Arti* and other as well), who have garlanded him with the most glorious acclamations. [Note by Averardo de' Medici]

And oh! were I not so lacking in information about the life and works of this illustrious woman, how I would have wished to enrich these *Memorials* with accounts, and illustrate for their erudite readership the paintings, dedicating to this task the time that they deserve. What we know with regard to her person is that she had a graceful form, carried with much grace and enlivened with a beautiful complexion.* And who knows: perhaps Nature, that benign mother, wished with this valuable gift to signal her gratitude in advance for a daughter who would go on to become her greatest ornament? It is known that in addition to having wealth from her parents and through inheritance, she was finally married in 1615 with Pierantonio Schiattesi [sic], about whom we know nothing but his name.

Although it would be right to assume that a woman endowed with such rare beauty and furnished with

* Such was the exquisite beauty of Artemisia that her mere portrait, carried out by the famous Romanelli, and by her own hand ornamented with a lovely wreath of flowers rendered with a masterful touch, was sufficient to spark the strongest and most violent fits of jealousy from the fair sex. The well-known humorous story in relation to this is in Baldinucci [p. 159-60 in this edition]. [Note by Averardo de' Medici]

Opposite: St Catherine, 1618-19

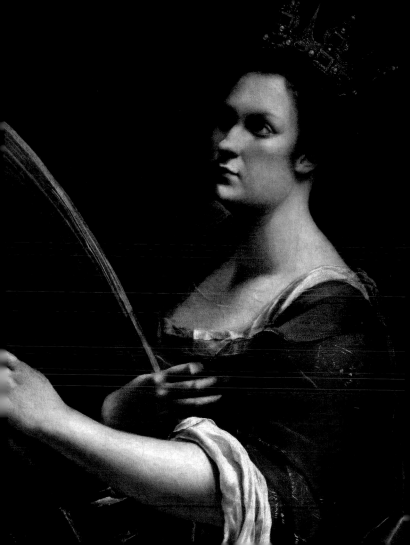

such wealth, in addition to having attained excellence in art, would not wish to be united in marriage with a coarse and plebeian man, it would nevertheless seem that Schiattesi owes his only glory to the accomplishment of being chosen as the consort of such a worthy bride. Yet it is a meaningless exercise to vaunt charms, beauty, wealth, and prominent family connections, which, coming to their natural end will disappear into oblivion, when instead there is ample cause for admiring and celebrating with a better reason the real qualities that will ensure her immortality.

Her very first works were the portraits of great lords, in which Orazio had taken particular care to instruct her, and many of them would call upon her paintbrush in order to have their pictures made; and perhaps her shrewd parent had set her on the path of this kind of painting since it was the easiest means of gaining access to the finest picture galleries and palaces and of making the acquaintance of some of the most magnificent patrons for whom one could ever work. Yet while Artemisia carried out large portraits, she did not abandon her interest in small-scale subjects, painting the fruits and flowers for which she had a special inclination, attaining

Opposite: Portrait of a Gonfaloniere, 1622

astonishing results.* The latter is a genre that truly requires greater intelligence and ingenuity because of the nature of the work, even though it might seem slight due to its physical dimensions. And in the realm of flowers, has there even been such an expert naturalist who understands the varieties of the species and the beauty of the structure, the multitude of colours, the liveliness and the curiosity of the forms? Who understands which of these is encased in a woody stem and which is in a supple one; which of these rises from the ground encircled by a single leaf and which is surrounded by a hundred leaves of which some are delicate and damaged and others thick and sturdy; which of these branches out like an umbrella and which is shaped like a trumpet; and which glows like a high flame and which like burning embers and which combines diverse colours. And the same erudition would apply to the fruit, a subject no less vast and important than flowers.

Yet Artemisia did not stop here, for this would have been too narrow of a boundary for her grand ideas.

* Gentileschi's lifelike and elegant floral still lifes are on display in the most distinguished galleries in Italy and abroad as supreme representatives of their genre, for which reason they were celebrated by the abovementioned authors. [Note by Averardo de' Medici. No floral paintings by Artemisia are known today]

It may be true that many noteworthy authors have asserted that she excelled only in small pictures and in the depiction of life-size figures* but was less at home with the large and complex ones. However, with all due respect to those who have espoused such claims, even this realm was illuminated by the excellence of her art. Quite famous are two famous and very large paintings on the side walls of the apse of the Cathedral of Pozzuoli, whose stories of *St Januarius in the Amphitheater Surrounded by Wild Beasts* and the *Beheading of St Januarius* are represented by Artemisia with many figures.¹ To these one should add two stupendous

* Among the works by Artemisia of this sort, particular mention should be made of a painting that is admired in Naples in the Galleria Filomarino of the Dukes della Tone, and which represents in life-size the young St John the Baptist in the desert, as he sleeps. The figure's impressive character as well as its natural and graceful pose, the soft and luminous impastoed paints, and the exquisite combination of bright colours that distinguish this important canvas have often produced such effects that even among the most expert connoisseurs it is immediately assumed to be one of Guido Reni's most prized works. [This painting is now lost.] [Note by Averardo de' Medici]

1. In fact Artemisia executed three paintings for Pozzuoli in 1636-37: one corresponds to the first mentioned by de' Medici but is now known as *The Martyrdom of St Januarius*; *St Proculus of Pozzuoli and his mother St Nicæa*; and the *Adoration of the Kings* (ill. p. 31)

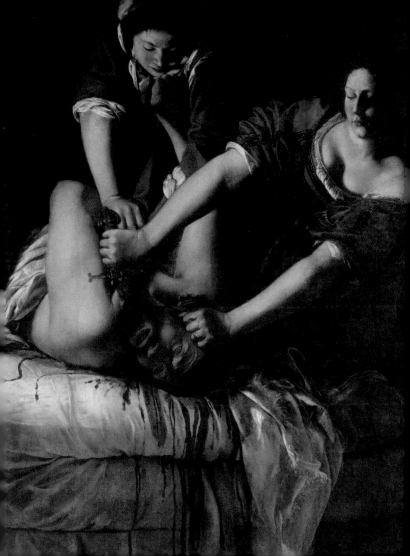

works that are still located in our city of Florence. One of them adorns the Royal Gallery and shows Judith in the act of severing Holofernes's head from his trunk — a work conceived with such perfection and painted with such lifelike colours that it inspires revulsion in everyone who looks at it.[1] The other, of which I am the lucky owner, represents Susanna as she leaves her bath, and it is painted with such skill, delicacy, and texture that you can almost feel — in a manner of speaking — the softness of her beautiful skin with your hand, leading awestruck viewers to marvel at the incredible artistry by which we perceive the gravity of the chaste heroine's reaction, the whiteness of her flesh, as well as her modesty, and by which we perceive the seething lust in the eyes of those brazen Elders who have just begun salaciously ogling her from the top of a balcony.[2]

Not by the common path did Artemisia come to attain such excellence in art. Having learnt the fundaments of drawing and design from her father and her uncle, her daily progress in painting and the studious

1. Uffizi, Florence (ill. p. 78) 2. Pinacoteca Nazionale di Bologna (ill. overleaf)

Opposite: Judith beheading Holofernes, c. 1612-13

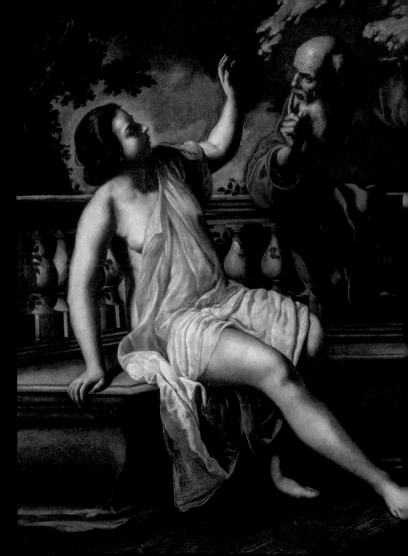

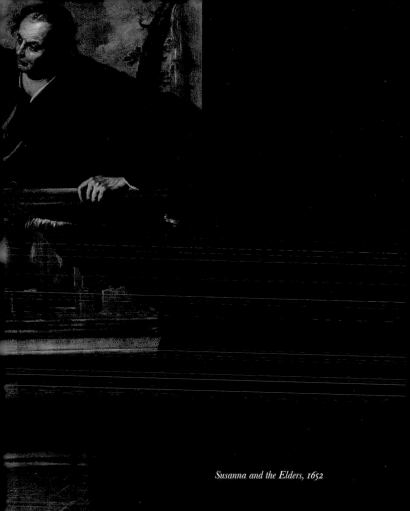

Susanna and the Elders, 1652

examination of the best paintings of her homeland and the surrounding territories did not sufficiently satisfy her bright intellect. For anyone who wishes to attain excellence, it is necessary to leave the confines of one's native soil. Such as have done great men, so has Artemisia, who aspired to undertake long journeys and visit many cities in the company of her talented father, in order that she might acquire good taste through the deep contemplation of the stupendous paintings that adorn the palaces and temples of Europe's cultural capitals, this being the only way to perfect those intellects that, magnanimously detesting all that is easy and pedestrian mediocrity, always strive for excellence in their works. And what rewards await he who at the same time succeeds in uniting excellent works with a knowledge of Nature. That knowledge is gained no less by means of studying the great Picture of Nature — which, among other things, offers an abundance of objects, the beauty of its products, and the variety of species — and recognizing how, both in kind and quantity, it is not possible to compete with such exquisite copiousness in disposition, intensity of expression, and vivid colouring, such that [painted things] appear both to move and to have life, than by means of the even more essential philosophical meditation upon human behaviour, which is very

useful for fuelling the imagination, awakening talent, and forming judgment through the apprehension and examination of the good and the true.*

In order to further clarify my argument, I take the liberty of calling on the Poet as an example. I say therefore that if for a Poet it suffices to read the good works written by those who preceded him, and if a Painter seeks only to admire the masterpieces of art, excellent though they may be, the former will become but a boring imitator of what has already been said by others, and the latter will become but the servile imitator of other artists' styles. Therefore if both the one and the other were to examine with perspicacious judgment Nature and her marvels in both their physical and their moral dimensions, fashioning by means of this education an individual style and an individual manner, the results would bring the canvases to life and animate the written pages, and I would not be

* Artemisia's painterly acumen in sketching was the fruit of the most useful theories of art, as well as similar deductions made while observing thoughtfully the natural and fantastic forms of beauty and by means of the erudite correspondence she maintained with the literati of her era, as seen in her learned letters, especially those she wrote to her patron and friend the Commendatore Cassiano dal Pozzo, which are included among the *Lettere Pittoriche*, vol. I, p. 225, Rome [see pp. 105-14 in the present volume]. [Note by Averardo de' Medici]

nearly so offended by such mistakes of judgment as for instance a pensive Sybarite, a soft-hearted Thracian, and a severe Spartan adorned with flowers. And I would consider the Poet worthy of such a great designation, and the Painter an original and creative thinker.

But perhaps I have got carried away with eloquence? And did not Artemisia by chance attain the glory of becoming an innovator and a teacher of others? Yes, certainly she attained that glory: and I would add that she was an innovator and a teacher of the most discriminating. As proof of this there is the fantastic testimony written by a painter who was much admired in his age, Bernardo De Dominici, and it is found in the life he composed for Cavalier Massimo Stanzioni, which I am duty-bound to repeat here precisely:

> At that time it came to pass that Artemisia Gentileschi arrived in Naples with her consort, and because she came accompanied by the written recommendations of the Viceroy in that period, and of other Neapolitan lords in addition, there was a great frenzy that spread throughout the city regarding her paintings, and particularly the portraits of important individuals she had carried out with such excellence[...]. Massimo

did not disdain to go to see her paintings, and to watch this talented Paintress while she worked, and having struck up a friendship with her, he had the pleasure of watching her paint every day. Moreover, he found himself so drawn to the radiance of the beautiful palette she used that he declared his desire to imitate her: and rightly so, since she spoke of having made every effort to achieve the exquisite palette of her master Guido [Reni], who had painted in Rome for Pope [Paul] V. Therefore Massimo, being modest, humble, and wise, set himself to copying Artemisia's small paintings of historical subjects, in which she was quite good, as well as her big, multi-figure history paintings, in which she was less successful. Artemisia admired his spirit, his application, and the ease with which he emulated her works, and she encouraged him to pursue the making of complex history subjects, given that portraits served only as a means of acquiring the good graces of those who might then give him more worthy commissions. For these reasons, and also on account of his own inclinations, he devoted his energies to the invention of compositions. But while listening to his teacher one day as she praised Guido once again, and by chance

Overleaf: Corisca and the Satyr, c. 1635-37

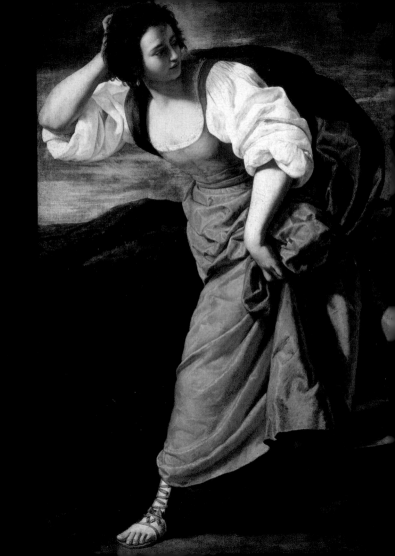

also his teacher Annibale Caracci, Massimo was overcome with such burning desire that he waited only long enough to finish the painting he was working on and then he left for Rome.

And while it is the case that all this ought to prove to anyone that Artemisia truly reached the rank of an innovator and a master, nevertheless there is yet additional confirmation from the opinions of the most sophisticated artists, who unanimously declare that she had a style and an approach that was utterly original, and her way of working with the paints ['un impasto di colori'] fully revealed the living quality of the flesh, uniting all at once texture, delicacy, singular grace, and good taste, such that her paintings combine the best of Guido and Domenichino, and her canvases are often mistaken by the great connoisseurs for the creations of both of those masters.

But how is it that Artemisia, being the daughter of Orazio who was the full brother of Aurelio Lomi, as is plainly evident from their baptismal records, along with the fact that they are both called sons of Giovan Batista di Bartolommeo Lomi, and then becoming the wife of Schiattesi, despite all of this she has always been commonly known with the name Gentileschi, even among painters? If we are to trust

[Filippo] Baldinucci — as is only fitting in his case, given that he is a diligent investigator of even the most trifling questions — then it derives from the donation or inheritance that Desiderio de' Gentileschi, her maternal uncle as well as an office-holder at the Castel Sant'Angelo in Rome, gave to her father Orazio with the obligation that the latter take his surname; yet it remains to be explained how the heirs or donors managed to silence the memory of the ancestral house of the Lomi, an illustrious house, in favor of the obscure and inherited house of the Gentileschi. Perhaps, in addition to the just-mentioned obligation, there was a certain gratitude and honouring of the generous benefactor, as well as the influence of widespread gossip arising from the bequest, due to the fact that the larger and more sizeable such bequests are, they more likely it is that the benefactor's surname will ever be on people's lips. That Artemisia even after marrying Schiattesi was continuously called by the Gentileschi surname is probably due to the fame of her father's art as well as her own, which in both cases was celebrated by the whole world and applauded under the famous name of the Gentileschi, just as would occur in the case of two renowned female poets, Faustina Maratti and Francesca Manzoni, who were continuously called by their maiden names, as is the case even

today, despite being married into the illustrious families of the Zappi of Imola and the Giusti of Milan, respectively.

It is much more difficult to assert how long she lived, and where and when her days came to an end. With all likelihood, she died in Naples, not only because she carried out many paintings there, but also because it is well known that she spent the better part of her life there. Moreover, although it has been written that she passed away in 1640, it is nevertheless certain that even in 1652 she was still painting brilliantly, as demonstrated by the inscription dated with that year on the acclaimed painting of the Susanna: and therefore it is unquestionable that she lived well into her sixties.*

* Thanks to a distinguished Florentine citizen who presided over the sumptuous restoration of the church of S. Giovanni dei Fiorentini in Naples in 1785, we have the reliable notice that on that occasion a large marble gravemarker was lost, although it is not known whether it was destroyed or merely covered up under the new pavement; that stone, which had formerly been near the chapel of the Riccio family, was inscribed in its center with these words: HEIC ARTIMISIA. Perhaps this brief epigraph, like the famous one in Perugia reading OSSA BARTOLI, was meant to point to the location of her remains and to invoke simply by means of her first name a most fitting eulogy for the outstanding painter we are celebrating? [Note by Averardo de' Medici]

ALESSANDRO MORRONA

Artemisia Gentileschi

1792

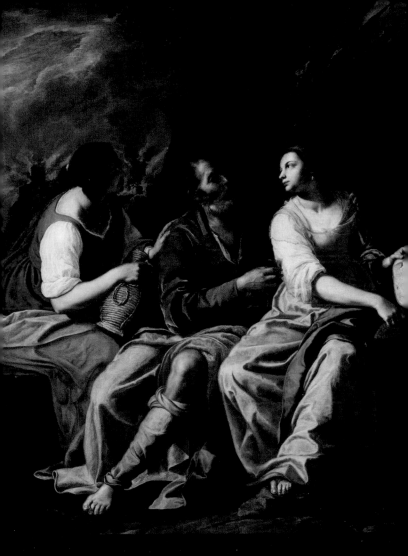

As everyone knows, with regard to the lovely art of painting, the fair sex also can boast of its bright stars of which it has no less in the realm of learning than in the realm of the Muses. Among these, Artemisia Gentileschi occupies a very exalted place, and therefore I am eager to include her here among the other highly renowned Pisan painters, and to sing the praises she so deserves.

She owed to Orazio Lomi Gentileschi her birth, which occurred in the year 1590, as well as her superior instruction in drawing. Not only by means of education and the soundest teachings did he pass on this knowledge to her, but also through the secret power of her forefathers' blood, for it is all too true what they say:

> Qui viget in foliis venit a radicibus humor
> Sic Patrum in natos abeunt cum semine mores.*

Nature joined forces with paternal care to give great advantages to Artemisia, endowing her refined soul with an extraordinary talent, and ornamenting

* 'The sap that glistens in the leaves comes from the roots, just as character passes from father to child with the seed.' (Battista the Mantuan)

Opposite: Lot and his daughters, c. 1636-38

her bodily aspect with the most beautiful and attractive forms. It is unquestionable that, by reason of these two very fundamental qualities, she did not lack for patrons and admirers. Among her many suitors in Rome, the painter Agostino Tassi was smitten with her, but the outcome of his affections was not a happy one. Passeri, himself a painter and poet, recounts that after being accused (whether rightly or wrongly) of excessive familiarity with his beloved Artemisia, beautiful in appearance, and very charming, Agostino endured prison and public whippings; and because of his mistrust of her, there was mutual aggression between the those two men. Finally, through the efforts of their friends, these bygone hostilities were forgetten, and they began to get along again, and their friendship became closer and more affectionate than ever, as I said in the preceding paragraph. [...]

Artemisia resembled her father with her keen wit, as manifested above all by her letters, and with her instinct for gracefulness, and thus in this sense as well we are justified in invoking that saying of [Mantuan's] that was cited above. To sum up, our immortal Paintress was supremely skilled in making portraits with elegant taste and true resemblance, in making history scenes with impeccable mastery, and in making realistic still lifes. With regard to her fervid imagination,

which is attested to by her *Judith* above all, we would do well to remember that Benedetto Averani said of her that she 'excelled in the art of painting' ['pingendi arte praestitit'], and that she rose above all other women painters to attain the highest level of honour.

Finally, after deep reflection, it can be stated that Artemisia's way of painting was recognizably hers alone, yet at the same time it was not so different from, nor better than, her father's style; it was influenced by Guido's Roman works and even more so by Domenichino's Neapolitan period — which overlapped with her own Neapolitan period. With the praises here above we have made an earnest tribute to a great woman who shone brightly in an age in which the Fine Arts flourished. We conclude thus, with the words Ariosto rightfully said of the fair sex: Women have attained excellence in all of the arts to which they have set their minds.

List of illustrations

All works oil on canvas unless stated otherwise

Illustrations pp. 1, 2, 7, 8, 10, 21, 31, 33, 66, 80, 106, 109, 112-113, 124, 129, 132, 152, 154, 167, 168, 172 and 174-75 Wikimedia; pp. 4, 12-13, 18, 40, 70-71, 84, 98-99 and 186 Google Arts & Culture; pp. 24-25 Metropolitan Museum of Art; pp. 27, 88-89 and 120-121 courtesy of the collectors (photograph pp. 88-89 by Dominique Provost, Brugge); pp. 76, 162, 180-81 author; p. 116 Bridgeman Art Library; pp. 134-35 christies.com; p. 139 sothebys.com; p. 156 Alessandra Masu

© 2021 Pallas Athene (Publishers) Ltd.

Published in the United States of America in 2021 by the J. Paul Getty Museum, Los Angeles
Getty Publications
1200 Getty Center Drive, Suite 500
Los Angeles, California 90049-1682
getty.edu/publications

Distributed in the United States and Canada by the University of Chicago Press

Printed in China

ISBN 978-1-60606-663-8
Library of Congress Control Number: 2020937438

Published in the United Kingdom by Pallas Athene (Publishers) Ltd.
2 Birch Close, London N19 5XD

Alexander Fyjis-Walker, *Series Editor*
Special thanks to Rachel Barth

Front cover: Artemisia Gentileschi, *Self-portrait as a lutenist*, 1616–18. Oil on canvas,
77.5 x 71.8 cm (30½ x 28¼ in.). Wadsworth Atheneum, Hartford, Connecticut.
Photo: Bridgeman Images

Note to the reader: Sheila Barker provided translations of texts by Cristofano Bronzini, Averardo de'
Medici and Alessandro Morrona, and of all the letters (except of those to Francesco Maria Maringhi
and Christine de Lorraine, which are by Alexander Fyjis-Walker). The Life by Filippo Baldinucci
was translated by Julia Dabbs, assisted by Anthony Colantuono and Pieranna Garavaso; it was
published in *Life Stories of Women Artists, 1550-1800* (Ashgate, 2009), pp. 147-50, and is reproduced
by generous permission of Professor Dabbs. The trial testimony is selected from the complete
testimony translated by Mary D. Garrard and Efrem G. Calingaert, published in *Artemisia
Gentileschi* by Mary D. Garrard (Princeton University Press, 1989), pp. 403-88, and is reproduced
by generous permission of Professor Garrard and Princeton University Press.